ARTP

ART

24 HOUR RENEWAL HOTLINE 0845 607 6119
www.cornwall.gov.uk/library

one and all — onen hag oll

FROM DEATH TO DEATH AND OTHER SMALL TALES

MASTERPIECES FROM THE SCOTTISH NATIONAL GALLERY OF MODERN ART AND THE D.DASKALOPOULOS COLLECTION

NATIONAL GALLERIES OF SCOTLAND

Published by the Trustees of the National Galleries of Scotland to accompany the exhibition, *From Death to Death and Other Small Tales: Masterpieces from the Scottish National Gallery of Modern Art and the D.Daskalopoulos Collection*, held at the Scottish National Gallery of Modern Art, Edinburgh, from 15 December 2012 to 8 September 2013.

Text © the Trustees of the National Galleries of Scotland

ISBN 978 1 906270 57 5 [English]
ISBN 978 1 906270 60 5 [English/Greek]

Designed and typeset in Minion and Embarcadero by Dalrymple
Printed in Belgium on Hannoart Silk 150gsm and Arcoprint Milk 100gsm by DeckersSnoeck

Front cover: Robert Gober, *Untitled*, 1991 (detail) D.Daskalopoulos Collection

Back cover: René Magritte, *The Bungler (La Gâcheuse)*, 1935 (detail) Scottish National Gallery of Modern Art, Edinburgh

Title page: Sumo Design Ltd

This exhibition has been made possible with the assistance of the Government Indemnity Scheme provided by Scottish Government.

The proceeds from the sale of this book go towards supporting the National Galleries of Scotland. For a complete list of current publications, please write to: NGS Publishing at the Scottish National Gallery of Modern Art, 75 Belford Road, Edinburgh EH4 3DR or visit our website: www.nationalgalleries.org

National Galleries of Scotland is a charity registered in Scotland (no.SC003728)

NATIONAL GALLERIES SCOTLAND

RICHARD FLOOD is Director of Special Projects and Curator at Large, New Museum, New York

KEITH HARTLEY is chief curator, Scottish National Gallery of Modern Art, Edinburgh

LUCY ASKEW is senior curator, Scottish National Gallery of Modern Art, Edinburgh

CONTENTS

7 FOREWORD
Simon Groom/Dimitris Daskalopoulos/Sir John Leighton

9 COLLECTING DASKALOPOULOS
Richard Flood

17 NIETZSCHE AND FREUD AND THE ART OF THE BODY
Keith Hartley

39 FROM DEATH TO DEATH AND OTHER SMALL TALES
Lucy Askew

49 THE EXHIBITION

137 ARTISTS' BIOGRAPHIES AND LIST OF WORKS
Lucy Askew, Lauren Logan and Elizabeth Manchester

151 SELECT BIBLIOGRAPHY

Simon Groom
Director, Scottish National Gallery of Modern Art

Dimitris Daskalopoulos

Sir John Leighton
Director-General, National Galleries of Scotland

FOREWORD

This exhibition brings together two different, and very distinctive, collections. Just as a collection assumes an identity greater than the sum of its constituent parts, so the exhibition, by bringing together these collections, reveals powerful new readings of both the collections and the works within them.

Amongst the common themes that run through the extensive holdings of the D.Daskalopoulos Collection, the notion of the body as a source of creativity and the vessel of existential, social and ideological struggle is a compelling and repeatedly examined motif. The idea of the body has a special resonance with the Scottish National Gallery of Modern Art collection. As well as the substantial holdings of work by Joseph Beuys, from which the title to the exhibition is taken, the Gallery also houses a rich collection of works by Surrealist and Dada artists such as Hans Bellmer, Balthus, Otto Dix, René Magritte and Picasso, for whom the body was a powerful theme. The exhibition offers a unique opportunity to explore the many and varied approaches that artists have taken over the past century when dealing with this most fundamental of subjects.

Bringing together over 120 works, the exhibition is displayed in pairings or as groups to draw out commonalities and differences between both collections. Through exciting and often surprising configurations, the exhibition stages confrontations between the past and present, sculpture and painting, expressive and minimal forms, to illuminate the diverse ways in which artists have approached the subject of the body. Whilst allowing works from both collections to be shown in a dynamic new context, it also allows an opportunity to see a large number of major pieces by artists whose works are rarely seen in the UK, such as those by David Hammons and Robert Gober. In so doing, the exhibition not only introduces us to new or unfamiliar works, but hopefully allows us to view works that may have grown familiar with new eyes.

We are indebted to many for their work in having contributed to make such an innovative exhibition possible. Thanks first and foremost are due to the curators of the exhibition, Keith Hartley and Lucy Askew, who were well assisted by Lauren Logan, from the Scottish National Gallery of Modern Art. We are also extremely grateful to them for their perceptive essays that follow, as we are to Richard Flood, Director of Special Projects and Curator at Large, the New Museum, New York, for his insightful text. We owe an especial debt of gratitude to Ioanna Vryzaki from the D.Daskalopoulos Collection for being everywhere at all times in her management of all aspects of the exhibition. We would also like to thank Dimitris Paleocrassas, François Chantala, Thomas Dane and Calum Sutton; Robert Dalrymple for the catalogue design; at the National Galleries of Scotland, Cassia Maria Pennington, for overseeing the movement of works, Cai Conduct and his able team for transforming the gallery in its entirety, Anne McMeekin for the distinctive marketing, Christine Thompson for the catalogue production, and Sarah Saunders and Helen Monaghan, with Elina Kountouri at the NEON, for putting together a major programme of talks and events to support the exhibition. Finally, we are indebted to the artists, their studios and galleries, without whom there would be no exhibition.

The health of
the eye seems
to demand a
horizon. We are
never tired, so
long as we see
far enough.

RALPH WALDO EMERSON[1]

RICHARD FLOOD

COLLECTING DASKALOPOULOS

Collecting – real collecting – is a blood sport. Whether it is salt and pepper shakers or Etruscan sarcophagi that are the objects of attraction, it matters not a whit; what matters is the passion of becoming one with the goal. The goal transmutes into a part of the collector's psyche – something capable of being measured, like heartbeats, pulse or truthfulness – and the real collector becomes increasingly comfortable being defined by the quality and originality/authenticity of what is being collected. Once a private collection is put on public display, it functions as a biography written by the supervising curator (hopefully in collusion with the collector) whereby the public is invited to puzzle out the psychosexual, scholarly, vainglorious, pedagogical, flirtatious, egalitarian and delicious variety of the collector's biography. Once a private collection becomes public knowledge, things begin to change. A legion of voices rise up as one martial chorus offering praise, advice, dire ruminations, acceptance, rejection, confirmation of status, degrees of vulnerability.

The exhibition represented by this catalogue is the third interpretation of the D.Daskalopoulos Collection since 2010. The first was London's Whitechapel Gallery's *Keeping it Real: An Exhibition in Four Acts: The D.Daskalopoulos Collection*. Divided into a quartet of topics – Corporeal, Subversive Abstraction, Current Disturbance and Material Intelligence – the exhibition lasted a year and fulfilled a variety of pedagogical goals. As selected by curator Achim Borchardt-Hume and given monologues and dialogues in each of

1. Ralph Waldo Emerson, *Nature* (1836), Harmondsworth, 1982, p.43.

2. Nancy Spector, *The Luminous Interval: The D.Daskalopoulos Collection*, quote of Dimitris Daskalopoulos from *Curating Rooms in my Head: Dimitris Daskalopoulos in conversation with Nancy Spector*, Guggenheim Museum, New York, 2011, p.20.

its installations, the collection conveyed a kind of discreet modesty which served its debut quite nicely. The next iteration of the collection was something entirely other. Mounted in 2011, *The Luminous Interval: The D.Daskalopoulos Collection* occupied a vast geographic realm at Bilbao's Guggenheim Museum. Curated by Nancy Spector and Katherine Brinson, the *Interval* was high opera to the Whitechapel's chamber ensemble. A parade of spectacular installations snaked throughout the museum and, where there was not an installation, the curators created one by uniting a variety of works and placing them on a bevy of low pedestals shaped like flattened, floating icebergs. Most importantly, the amazing scope of the collection was visible. Now *From Death to Death and Other Small Tales: Masterpieces from the Scottish National Gallery of Modern Art and the D.Daskalopoulos Collection* unites two extraordinary bodies of work resembling something rather like a recital by two master tenors blending their repertoire and highlighting their differences. Traversing two centuries and introducing an artist such as Hans Bellmer to Sarah Lucas, *From Death to Death* is concerned with connoisseurship and the frisson of historical conversation. After a nicely refined edit of the collection in London and an expansively boffo production in Bilbao, the elegant contextualisation of Edinburgh seems like the perfect punctuation for the collection in its third year in the public domain.

The D.Daskalopoulos Collection dates back to 1994 when, still unnamed, it began to grow in a direction that would, by 1999, no longer have the contours of a private undertaking. The ambition of the acquisitions and the preponderance of large-scale installations could no longer masquerade as a hobby; it was too motivated as an activity, and certain specific tendencies were developing with consistency. As has been noted on a number of occasions, the collection is very body oriented, one might even say body-dependent. Dimitris Daskalopoulos, the author of the collection, has spoken and written eloquently about what he is looking for and what he hopes to achieve:

> I marvel at the inspired, creative existence of the human being. A finite, vulnerable organism which despite its inherent knowledge of its restrictions and finality is simultaneously capable of such vision, ingenuity, imagination and resourcefulness. An existence that exhibits a constant will to prevail over the inexplicable, to conquer the unfathomable complexity of what surrounds it. A being that, driven by a will to live, feel, enjoy and create can overcome any adversity, whether external or of its own making.[2]

In these words there is an almost rapturous acceptance of the power that creativity brings to humanity. Daskalopoulos also talks very clearly about the real and imaginary pleasure he gains from collecting: 'By putting different works of art in dialogue, I try to create an imagery that expresses this constant tension between life and death, between futility and immortality, an image of the human struggle and its propensity towards optimism and endeavor instead of nihilism and abandon.'[3] Certainly there is moral purpose here as well as an expression of spiritual

3. Communiqué from Dimitris Daskalopoulos received on 6 November 2012.

4. Ralph Waldo Emerson, *Nature* (1836), Harmondsworth, 1982, p.47.

endeavour. This has nothing to do with a need to amass things but rather a reason to see things more clearly, to reflect on the mysteries through objects of empowerment. The philosophy embedded in Daskalopoulos's approach feels very close to true Transcendentalism as espoused by Ralph Waldo Emerson, or Sensualism as prototyped by Aristotle and preached by John Locke. Both modes of reason espouse the inherent freedom to respond and the primacy of the individual. A passage from Emerson's *Nature* runs a parallel course to Daskalopoulos's observations and suggests a philosophical formulation and atavistic point of departure:

> The production of a work of art throws a light on the mystery of humanity. A work of art is an abstract or epitome of the world. It is the result or expression of nature, in miniature. For, although the works of nature are innumerable and all different, the result or the expression of them all is similar and single … The standard of beauty is the entire circuit of natural forms, the totality of nature; which the Italians expressed by defining beauty 'il piu nell' uno.' Nothing is quite beautiful alone; nothing but is beautiful in the whole. A single object is beautiful only insofar as it suggests this universal grace … Thus is art, a nature passed through the alembic of man. Thus in art, does nature work through the will of a man filled with the beauty of her first works.[4]

In October 2012, Dimitris Daskalopoulos and I had a conversation that became increasingly about the representation of the body in his collection. The first comment he made on the topic was, 'We are frail, we are simple. The body is a receptacle for everything … The body is the marvel of human existence that is resilience and creativity.' Speaking of the art itself, he continued: 'The visceral part of it reminds us of our body and our fluids that we need to be alive and to have emotions – so passion!' On the subject of multiple works by a select group of artists (Matthew Barney, Robert Gober, Kiki Smith are some), the collector answered: 'I wish I could have done it more. I'm looking into an artist because the work is compatible to my sensibility.' Regarding the more than sixty women in the collection, Daskalopoulos said, 'The collection has work by women who are using their muscle; not one of them is doing something that is acceptable. They're revolutionaries. Nothing passive.' On the topic of hit lists, 'I was never looking for nationality, age, gender. It's not important to meet the artists; it's the power emanating from the work. When I look for the human element, it's there across gender and nationality.' How do historic pieces fit in (Carl Andre, Lynda Benglis, Joseph Beuys, Robert Morris, Dieter Roth and a handful of others)? 'I willingly decided to have some anchors but I held back on that because it can draw you into the past and make you disintegrate into the greatness of all past art and you don't have a collection, you have trophies.' Finally, I asked about his reaction to curators editing the collection to suit their aesthetics, to which he replied: 'I've really enjoyed having the curators go at it as they feel. Three different curators look at it and they make totally different interpretations so that's how I want to see it.'

What Daskalopoulos has in his collection are approximately fifty large-scale installations and moving-image projections by artists like Kutlug Ataman, Phyllida Barlow, Matthew Barney, John Bock, Helen Chadwick, Paul Chan, Abraham Cruzvillegas, Robert Gober, David Hammons, Mona Hatoum, Thomas Hirschhorn, Paul McCarthy, Wangechi Mutu, Paul Pfeiffer, Pipilotti Rist and Kiki Smith. They run from definitively important, say Thomas Hirschhorn's *Cavemanman*, to perfect examples, Ernesto Neto's *It Happens When the Body is Anatomy of Time* [22], and Wangechi Mutu's unabashedly gothic, morbidly mad *Exhuming Gluttony: A Lover's Requiem*. The installations tend to be expensive to store, difficult to maintain, labour-intensive to set up and visceral to experience. They also account for one of the great differences between the D.Daskalopoulos Collection and others. Very few collectors have made a similar commitment whereby their works are rarely available to them. Of equal note is the collection's archival role in preserving the art of installation from the late twentieth and early twenty-first centuries. As regards the artists who are collected in depth, there is often a wealth of work that can further be utilised to create large, focused installations and/or enhance key pieces. This is particularly true of artists like Matthew Barney, Paul Chan, Robert Gober and Kiki Smith. At first glance, this group does not appear particularly united but, as time passes, one becomes aware that sorrow suffuses much of the work.

There is a sense of loss and vulnerability that courses through the collection. Gober is perhaps easiest to understand in this context. His *Dog Bed* [46], and *X Crib* [6] are obviously about what is missing – the dog and the child. Perfect playmates but vanished! The child in particular leaves behind a crime scene where X marks the spot and the spot is the X chromosome (which determines the sexuality of a foetus; if a male has two X chromosomes, sexual organs and testosterone levels are compromised). It's a crib to torture not nurture, a trap to inhibit and warp both body and spirit. The child returns in the work of Mike Kelley where an untitled piece is composed of two floppy rag dolls linked like Siamese twins (or a doppelgänger or bipolar selves); it might well have been the doll for Gober's strayed child. In Kelley's work, the child is less strayed than abandoned. His dolly kids are caught playing games and interacting in social situations but they are just bits of fabric waiting for a parental animator like you or me.

Another conjoined piece, Bruce Nauman's *Small Butt to Butt* [45], could well be a portrait of a Eumenide slapped together out of spit and putty from a truckload of Route 66 road kills. The misbegotten creatures cancel each other out in a torture that condemns them to perpetual tantric bondage. Unable to move forwards or backwards, they/it can do nothing more than a blind sideways shuffle that will never lead to the evolutionary ladder. Louise Bourgeois's *Fillette (Sweeter Version)* [47] continues the dualities in the collection. While the sculpture portrays an enormous cock and scrotum, its title, *Little Girl*, is whimsically awry. Although I think it is unlikely that the sculpture

could corrupt an innocent (it could just as easily be an attenuated portrait of Jabba the Hutt), the work has the paleolithic power of the *Venus of Willendorf*. If we continue for a moment with Greek mythology, *Fillette* could also be a prop from Euripides' third-century BC drama *The Bacchae* or Aristophanes' *Lysistrata*. It captures the uniquely brutal humour that is pervasive in Bourgeois's work where bad sex and anxious laughter are often one and the same. Completely lacking in humour but related in archaic power is the art of Ana Mendieta, who fuelled her rage through the creation of rituals in which blood and earth are the key materials. Mendieta's raw feminism began in the 1970s and stood out because she became a grim Latina priestess/shaman starring in scenarios that seemed based on ancient agrarian ceremonies of propitiation and sacrifice. The late British artist Helen Chadwick used the body/her body in a lyrical ensemble of work including sculpture and self-portraits. While the work had aggressive tendencies, it was controlled by a refined sensibility. *Piss Flowers 1–12* [] is her signature piece, and the signature couldn't be more primal – her urine. Like animals urinating to claim their territory, Chadwick (and her husband David Notarius) peed in the snow, and Chadwick cast the negative spaces of the holes they made. The suite of bronzes resembles nothing so much as blanched toadstools. Yet the casts also have a topographic component in their resemblance to landscapes. Unlike Mendieta's work, the bodily fluid is nowhere visible but, like Warhol's oxidised paintings, the urine is the agent of alchemical change and a kind of involuntary self-portrait.

In direct contrast to Mendieta and Chadwick, an artist like Sarah Lucas celebrates her feminism by smacking it around and branding it with her audacity. She exploits her tomboy persona by bringing smoking and drinking, cursing and snogging into the core of her work. In the chain of Lucas's photographic self-portraits, it's as if she's playing the trouser role in a punk opera; it's believable, but not without her in-your-face attitude that stares you down. One of Lucas's most distinct qualities is her understanding of humour as a cathartic compositional element. It's very rare that an artist can make you laugh without compromising the gravity of their work – Lucas can. Paul McCarthy is another artist who celebrates laughter. Few are quite so at home with anarchic vulgarity as McCarthy who creates orgies of disorder in his videos. Nothing and no-one is sacred, and he takes particular delight in defaming the famous: people like Queen Elizabeth and George Bush. As in many of his videos, the collection's *Pirate Party* [] transcends bad taste and goes straight to the Valhalla of scatological masterworks.

Marina Abramović has, over the last decade, come to be emblematic of an historical kind of performance art involving duration, endurance, patience, hyper focus and hieratic presentation of self. Like Mendieta, her art began in the 1970s and has, over the years, held firm to its original blueprint. The steadiness of Abramović's vision has created a body of work that, while sexual, is never

5. Ibid., p.42.

erotic. Inevitably, Abramović always makes her performances quite pragmatic and direct – rather formal and impassive. *Cleaning the Mirror#1* [32] is a task-oriented act in which the artist cradles a dirtied skeleton in her lap and laboriously scrubs every part of it until it is clean and Abramović's fingers are bleeding from the effort. Unlike Mendieta, her art doesn't permit accidents but represents a job thoroughly inhabited. She too conjures a primal persona but, clothed in her unbreachable dignity, it is more an abbess than priestess. Unlike Abramović, Kiki Smith exposes masses of vulnerabilities. She mixes sweet and sour with a flourish that can lead to sculpture that is obsessed with bodily waste, gangrenous mortality and physical debasement while creating work that is as sweet as a posy. She generates works in gossamer papers and then in monumentalising bronze. She is an inventor of fairy tales and a cold-eyed recorder of pariah brides; she is a forensic poet and a purveyor of bodily fluids. Smith is not afraid of ugly, or of exposing the body's betrayal of the spirit. In Emerson's *Nature*, he writes: 'There is no object so foul that intense light will not make it beautiful.'[5] This would seem an accurate reflection on Smith's practice where there is nothing too raw – too exposed – for her to bring it into the light.

The presence of all five of Matthew Barney's *Cremaster* [14–19] films brings a major mythological resonance into the collection. Incorporating tales and characters from Celtic and Greek traditions as well as creatures from the artist's own pantheon, Barney spent eight years (1994–2002) spinning the non-sequential *Cremaster* saga (number 1 was filmed after number 4, and 5 was filmed before 3). The films travel across the United States to the Isle of Man and on to Budapest, Hungary. There are giants and dwarves, satyrs and sphinxes, magicians and murderers. Ursula Andress, Norman Mailer and Richard Serra play crucial authority roles and the superstar magician Harry Houdini (Mailer) is the nail on which much of the viral plot hangs. Barney's images are extravagantly profligate – a rodeo stadium made out of salt, molten Vaseline pouring down the ramp of the Guggenheim Museum, zombiefied horses racing in the mist at the Saratoga Race Course, mermaids in a water ballet in Budapest's Geller Baths. The cremaster muscle is itself the indicator of gender determination and provides the resistant heart of the *Cremaster* cycle. In the *Cremaster* films, gender assignment does not come easily; it is a journey replete with challenges and temptations in which Barney takes the role of a latter-day Theseus. The *Cremaster* saga also works as a summation of many of the collection's concerns and themes – mortality, sensuality, decay, rebirth.

Daskalopoulos has discussed how important the acquisition of Duchamp's *Fountain* [24, 25] was to the collection and of feeling that his responsibility to the piece necessitated it being in a public collection. Since its creation in 1917, *Fountain* has become one of the most important art works of the twentieth century. I think it will likely remain so well into the twenty-first. Presenting a urinal as an art object was obviously a provocation but one that opened a wealth of conversation that has helped

determine the course of Western art practice. The compatibility of the urinal's shape has reminded onlookers of everything from Buddha to the *Mona Lisa* and rewarded it with an easy classicism. It has been sorely abused and violently attacked but nothing has interfered with its self-contained complacency. It is the ultimate empty vessel, both a joke and an icon. Perhaps Robert Gober's *Untitled*, 1989 [59–6], installation with its *Male and Female Genital Wallpaper* embedded with eight pewter drains is the perfect surrealist setting for Duchamp's Dada *Fountain*. While the drains are in the same family with the urinal, it is another component in the installation that highlights the brilliant banality of it all with the magnificence of the everyday: *Bag of Donuts* 1989 [59, 61], which is in fact a laboriously crafted sculpture. It acts as a complete inversion of Duchamp's historic readymade by creating a painstakingly modelled illusion of a readymade. In the beautiful symmetry of creation both objects are art but, in addition to that, they are also ideas. And it is the primacy of ideas that makes the D.Daskalopoulos Collection a living conversation dedicated to the infinite variety of art. It is also a serious meditation on mortality.

There is more reason in your body than in your best wisdom.

FRIEDRICH NIETZSCHE[1]

KEITH HARTLEY

NIETZSCHE AND FREUD AND THE ART OF THE BODY

The body has always played a key role in the visual arts. Ever since one of our prehistoric ancestors placed his or her outstretched hand on a cave wall and blew pigment over it, humans have been fascinated by ways of fixing its shape, capturing its trace, in two or three dimensions.

Nearly all great civilisations have had the human figure as the main focus of their art. Sometimes the body was little more than a sign, a hieratic signifier for a human agent, part of a cosmic struggle between humanity and its gods – more concerned with the afterlife than the present. Other cultures put the human body centre-stage and extolled its beauty, its strength, its materiality. Wilhelm Worringer's (1881–1965) binary classification into abstraction and empathy, into two opposing kinds of art – one tending towards abstraction, stylisation and decoration, the other towards mimesis and realism – is still useful today as a way of approaching long-term shifts in artistic development.[2] Worringer's concept of abstraction posits fear in the face of unknowable, unmanageable space as the reason why some artists and civilisations retreat within to the safety of reason, geometry and two-dimensional design. It is for this reason that he is often cited as a key influence on the emergence of abstract art in the first decades of the twentieth century. However, if one takes a longer perspective on things, one could argue that it was precisely in the late nineteenth and early twentieth centuries that the stirrings of a new type of 'empathetic' art began. Up to then, depictions of the human figure had seen the body either as an active agent of the individual ego, carrying out actions

1. Friedrich Nietzsche, *Also sprach Zarathustra* [*Thus Spake Zarathustra*], first published in four parts, 1883–5; here translated by R.J. Hollingdale, London, 2003.
2. Wilhelm Worringer, *Abstraktion und Einfühling* [*Abstraction and Empathy*], Munich, 1908.

3. René Descartes, *Discours de la Méthode* (*Discourse on Method*), Leyden, 1637.

4. Friedrich Nietzsche, *Die fröhliche Wissenschaft* [*The Gay Science*], 1882; quoted in Friedrich Nietzsche, *Thus Spake Zarathustra*, translated by R.J. Hollingdale, London, 2003, pp.15–16.

willed by the conscious mind or as a passive recipient of external forces. In both cases the body was little more than an instrument or machine with no volition of its own. Especially since the Renaissance, artists had used the body to express emotions and reactions, but there was never any question of the body instigating those feelings itself. The mind was always in command.

This rationalist conception of what has become known as the mind/body problem was given its definitive and hugely influential formulation by the French philosopher and mathematician René Descartes (1596–1650).³ In his desire to reduce everything to rational principles, Descartes concluded that everything could be illusory or false except for one thing, the fact that he was thinking and that, therefore, the fact of existence should be based on this one premise: I think, therefore I am (*cogito, ergo sum*). He went on to construct a view of the universe as a rational machine, functioning according to fixed mathematical and physical laws, all based on the fact that his conscious mind was at root rational and logical. Not only did this theory see the macro-universe of nature as a machine but the micro-universe of one's own body as a machine as well, with the rational, thinking mind in complete control. This philosophy (since dubbed Cartesian) had a strong hold on the way intellectuals, scientists, writers and artists in France (and in many other European countries) thought about the world and themselves for the next three centuries. Things happened according to fixed laws which one by one were being discovered by scientists. Everything, including the way human beings behaved, was explainable, if one knew all the facts. There were some sceptics and some downright opponents of this overly logical view of the way things worked, most notably during the Romantic period, but by and large it remained the prevailing philosophical stance on mainland Europe well into the nineteenth century.

However, a massive change was heralded in the last quarter of the century by the publication of the works of Friedrich Nietzsche (1844–1900). Nietzsche's writings represented a thorough-going scepticism, almost amounting to nihilism. He rejected any notion of rational order in the universe and as such was opposed to everything that Cartesian philosophy stood for. In a particularly bleak passage in *Thus Spake Zarathustra* he wrote:

> The total nature of the world is ... to all eternity chaos, not in the sense that necessity is lacking but in that order, structure, form, beauty, wisdom and whatever other human aesthetic notions we may have are lacking ... Let us beware of saying there are laws in nature. There are only necessities; there is no one to command, no one to obey, no one to transgress ... Let us beware of saying that death is the opposite of life. The living species is only a species of the dead, and a very rare species.⁴

And yet, having delivered such a devastating critique of the way humans always seek to impose (their own) rational structures on things, he does not emerge hopeless and empty into a world without meaning. On the contrary, having established a *tabula rasa*, he looks for what remains and it is: that

5. See note 1, part one, 'Zarathustra's Discourses', pp.61–2.

he exists – *sum* rather than *cogito* – and he affirms this and all that life has to offer – its tragedies as well as its triumphs, its pains as well as its joys. The meaning of life lies in total affirmation (sometimes termed the 'will to power'), not in creating partial rational structures.

The effect of this 'transvaluation of values' (*Umwertung aller Werte*) was to remove reason from its throne of omnipotence as the summit of all human values and to look at the whole of what it is to be human, with mind and body unseparated. Instead of looking down on the body as a mere machine as Decartes had done, or even despising it as a weak vessel, prone to the temptations of the flesh, as Christianity had done, Nietzsche reinstated the body as a larger Truth which we had not even begun to understand. In a famous passage in *Thus Spake Zarathustra* he makes an ecstatic paean to the body that radically overturns three hundred years of Cartesian rationalism:

> ... the awakened, the enlightened man says: I am body entirely, and nothing beside; and soul is only a word for something in the body.
>
> The body is a great intelligence, a multiplicity with one sense ...
>
> Your little intelligence, my brother, which you call 'spirit' is also an instrument of your body, a little instrument and toy of your great intelligence. You say 'I' and you are proud of this word. But greater than this – although you will not believe in it – is your body and its great intelligence, which does not say 'I' but performs 'I'.

> What the sense feels, what the spirit perceives, is never an end in itself. But sense and spirit would like to persuade you that they are the end of all things: they are as vain as that.
>
> Sense and spirit are instruments and toys: behind them still lies the Self. The Self seeks with the eyes of the sense, it listens too with the ears of the spirit.
>
> The Self is always listening and seeking: it compares, subdues, conquers, destroys. It rules and is also the Ego's ruler.
>
> Behind your thoughts and feelings, my brother, stands a mighty commander, an unknown sage – he is called Self. He lives in your body, he is your body.
>
> There is more reason in your body than in your best wisdom. [...]
>
> Your Self laughs at your Ego and its proud leapings. 'What are these leapings and flights of thought to me?' it says to itself. 'A by-way to my goal. I am the Ego's leading-string and I prompt its conceptions.'[5]

Not only does this, and numerous other passages in Nietzsche's writings, attack head-on Descartes's separation of mind and body, demoting the thinking, reasoning mind into little more than a puppet of the body, but it also looks forward to Sigmund Freud's discoveries about the unconscious mind and its relationship with the conscious ego. For many thinkers, such as Freud (1856–1939), Nietzsche cut the ground from beneath rationalist thought or a simplistic, clockwork view of the universe. Meaning needed to be sought in more complicated relationships between things. For Nietzsche, having abandoned humanity alone in a chaotic universe, with no solace

6. Friedrich Nietzsche, *Die Geburt der Tragödie aus dem Geiste der Musik* [*The Birth of Tragedy out of the Spirit of Music*], Leipzig, 1872.

7. Friedrich Nietzsche, *Die Geburt der Tragödie aus dem Geiste der Musik* [*The Birth of Tragedy out of the Spirit of Music*], Augsburg edition, no date, p.33; present author's translation.

8. Ibid., p.38.

9. In 1904 Max Klinger (1857–1920) finished a bronze bust of Nietzsche (Städtische Galerie in Städelsches Kunstinstitut, Frankfurt).

10. The name Brücke (Bridge) that Ernst Ludwig Kirchner (1880–1938), Karl Schmidt-Rottluff (1884–1976), Erich Heckel (1883–1970), Max Pechstein (1881–1955) and Fritz Bleyl (1880–1966) chose for their youthful artist group was taken from Nietzsche's *Thus Spake Zarathustra*. In the opening 'Prologue' (section 4) Zarathustra said to the people: 'What is great in man is that he is a bridge and not a goal' (p.44).

11. In his *Memoirs* Giorgio de Chirico (1888–1978) writes about the crucial influence that Nietzsche had on him: 'the true novelty discovered by this philosopher … is a strange and profound poetry, infinitely mysterious and solitary, which is based on the *Stimmung* (I use this very effective German word, which could be translated as atmosphere in the moral sense), the *Stimmung*, I repeat,

of a unifying god, he then found new meaning for it in its very isolation, its very lack. Humanity had to *overcome* itself by building on what it had. If you are at rock bottom, the only way is up. And the only thing that people knew they had was their bodies. They, therefore, had to be affirmative and positive about their bodies and listen to what their bodies told them.

An early work by Nietzsche, written before he had worked out his ideas about self-affirmation, his philosophy of life, *The Birth of Tragedy* (first published in 1872) contains a vision of what this new more physical, more holistic approach to life might be.[6] He argues that Greek tragedy came about through a struggle between the Dionysian aspect of life, a reality undifferentiated by forms and laws – wild, spontaneous and physical – and the Apollonian, a reality structured by the intellect – calm, collected and ordered. Greek tragedy was, he argued, the highest form of art because it faced up to the nihilism of the world, it faced up to pessimism, and created art out of it. The noble, ideal world of Apollo was only possible because the dark physicality of Dionysus was embraced. The Reason of Apollo separates things into neat ordered rows; the Ecstasy of Dionysus binds things together in a physical and emotional unity. Nietzsche insisted that both principles were necessary to achieve the highest art, but the writers, artists, composers and dancers who were inspired by him and by this book were drawn irresistibly to the Dionysian force. After the rationalism and the positivism that had ruled the world for so long, people were looking for ways to express their feelings, to be closer to their affective natures. A renewed interest in Romanticism (especially in Germany) and the emergence of Symbolism were also signs of this shift. In the visual arts, the specific impact of Nietzsche's vitalism, and, in particular, of his Apollonian/Dionysian dichotomy, first showed itself in the work of the Swiss painter Arnold Böcklin (1827–1901). Böcklin animated his southern Mediterranean landscapes with figures and creatures from classical mythology. In some cases the creatures, such as the great god Pan, satyrs, centaurs and tritons, became the very embodiment of oneness with nature, with its forces and urges; symbols of the libido, of the Dionysian *Rausch* (ecstasy). In other cases, unknown ancient rites or mysteries are hinted at through processions and flaming torches. Perhaps these enact the 'terrors and dreads of existence'[7] that Nietzsche speaks about in *The Birth of Tragedy*, the unspeakable truths that we prefer to suppress, but which the Dionysian principle embraces, thereby enabling the noble and untroubled façade of the Apollonian culture to exist. The Apollonian Greek knew that (s)he was inextricably bound up with the 'titanic' and the 'barbaric' qualities of Dionysus. His/her whole existence, with all its beauty and restraint, rested on a concealed bedrock of suffering and knowledge, which was revealed to him/her again through the Dionysian principle. Apollo could not live without Dionysus.[8]

Nietzsche's direct influence on artists and thinkers continued into the twentieth century. Nietzsche placed a question mark over the extent to which our faculty of reasoning was in charge of

12. In his novel *Der Zauberberg* (*The Magic Mountain*), 1924, Thomas Mann (1875–1955) includes a chapter ('Schnee' – snow) which has at its heart an interlude that is directly inspired by Nietzsche's vision of classical Greek culture – Apollonian in its grace, calm and dignity, but hiding within it a Dionysian frenzy. The novel's hero, Hans Castorp, gets lost in the snowy Swiss Alps and falls asleep. He dreams he is in a warm Mediterranean landscape where beautiful young 'people of the sun' enjoy a carefree existence. In this vision of an earthly paradise he sees a finely proportioned temple and, wandering into its very sanctum, he witnesses a horrific sight: two half-naked hags tearing a small child to pieces and devouring it. Upon waking he considers the implications of what he has seen: 'Whoever recognizes the body – life – must also recognize death.' (Stockholm edition, 1966, p.684; present author's translation).

13. Friedrich Nietzsche, Also sprach Zarathustra [Thus Spake Zarathustra], first published in four parts, 1883–5; here translated by R.J. Hollingdale, London, 2003, p.14.

our destiny. Artists (such as Max Klinger,[9] Edvard Munch (1863–1944), the Brücke group,[10] the Dada artists and de Chirico[11]), authors (Thomas Mann,[12] Hermann Hesse, André Gide and Rainer Maria Rilke) and composers (Gustav Mahler, Richard Strauss, Arnold Schoenberg and Igor Stravinsky) all became fascinated by the dark primitive drives (often sexual) that civilisation tried to suppress. They saw that our bodies seemed to be more attuned to these urges; freed from rational control our bodies could be in harmony not only with these inner drives but with the natural forces that surround and flow through us at all times. At the turn from the nineteenth to the twentieth century the body became a touchstone for authenticity and natural purity, with the reform movement that ran from free-flowing natural clothing, through vegetarianism to naturism. When Munch (who painted a heroic portrait of Nietzsche in 1906) depicted a group of men striding out of the sea in 1907, he was celebrating the naked human body. Similarly, when the Brücke artists Ernst Ludwig Kirchner, Erich Heckel and Max Pechstein painted themselves and their friends naked at the Moritzburg lakes near Dresden in 1909–10, they were self-consciously trying to create an Arcadian image of unity between Man and Nature. The expressionist movement in Germany, of which they were a part, prized primitivism and spontaneity above sophistication and ordered control.

The Dada artists, traumatised by the mechanised slaughter of millions in the trenches of the First World War, by the way that human reason had been led astray by nationalist propaganda to create killing machines of unparalleled efficiency, found a welcome honesty in Nietzsche's debunking of all human self-deceptions. When Nietzsche wrote in *The Gay Science* (1882) 'Ultimate Scepticism, what then in the last resort are the truths of mankind? – They are the irrefutable errors of mankind',[13] the Dadaists, such as Hugo Ball (1886–1927) (who wrote his doctorial dissertation on Nietzsche), applauded and saw it as a way of starting from scratch, of forging a new world (or, at least, a new Europe) from a *tabula rasa*. Their weapon was nonsense, nihilistic humour and absurdity. Like mediaeval jesters they turned the world on its head and all reason into unreason. They called the integrity of the humanistic body radically into question. Had not men been little more than cogs in the ruthless machine of war and had not hundreds of thousands of them been reduced to grotesque agglomerations of prosthetic parts by the savagery of battle? George Grosz (1893–1959) created faceless automata to satirise the unquestioning obedience that people gave to politicians and industrialists. Otto Dix depicted the plight of limbless and blinded ex-servicemen in a dispirited Germany as if they were characters in a cruel comic-strip cartoon. Others, such as Marcel Duchamp and Francis Picabia turned human beings into mechanical parts, carrying out the basic functions of human life, such as reproduction and birth, in a never-ending robotic fashion. By upending a urinal, placing it on a plinth and calling it *Fountain*, 1917 [], Duchamp turns a quotidian receptacle of human waste into a potential source of life-giving water – at least, in this topsy-turvy world, where black can be white and

14. See A.H. Chapman and Mirian Chapman-Santana, 'The Influence of Nietzsche on Freud's Ideas', *British Journal of Psychiatry*, 1995, vol.166, pp.251–3.

15. Sigmund Freud, *A Difficulty in the Path of Psycho-Analysis*, Standard Edition, vol.17, p.143; quoted in Anna Freud's introduction to Sigmund Freud, *The Essentials of Psycho-Analaysis*, Harmondsworth, 1986, p.77.

16. André Breton, *Nadja* (1928), translated by Richard Howard, New York, 1960, p.24; quoted in David Lomas, *The Haunted Self*, New Haven and London, 2000, p.1.

17. André Breton, 'Manifesto of Surrealism' (1924), in André Breton, *Manifestos of Surrealism*, translated by Richard Seaver and Helen R. Lane, Ann Arbor, 1972, p.26.

wrong can be right, that could be an idealist's view.

Nietzsche has continued to be a direct influence on artists and writers up to the present day, but the most important of these was Freud. Although Freud denied, on several occasions, that he had read Nietzsche, he does in fact mention him in his writings and his correspondence.[14] Whatever the reasons for this denial, numerous scholars have pointed to the close analogies that exist in the ideas that both writers had about the human mind: the existence of the unconscious, the concept of repression, the way that dreams function and the projection of hostile feelings onto others by those suffering from paranoia. In essence they both questioned the view that the conscious reasoning mind was in total control of human actions, that as Freud memorably put it, 'the Ego is not master in its own house'.[15] Freud (and his followers) studied the workings of the unconscious using several tools and techniques: the interpretation of dreams, the study of automatic writing, the analysis of word associations and, above all, getting people to talk about themselves, their memories, their fears and their anxieties. What he hoped to do was to catch the mind unawares, so that it might reveal more than it intended. Using this information Freud produced several theories about how the unconscious and conscious minds interacted, about how the Ego was formed from earliest infancy, the relationship between the child and its mother and father, the creation of the child's sexual identity, the positing of the Oedipus complex and of castration fears, the way that repression worked, the possible causes of hysteria and paranoia, the various subdivisions of the unconscious including the Id, the possibility of the death drive 'beyond the pleasure principle'. To what extent these theories proved to correspond to clinical reality is another matter, but these psychoanalytical techniques and theories were hugely influential and fruitful in the fields of philosophy, sociology, linguistics, anthropology, and not least the arts.

Surrealism, is quite unthinkable without Freud's concept of the unconscious. André Breton (1896–1966), who did more than anyone to create the movement and who as its leader, welcoming new members and excommunicating others, said of psychoanalysis that it was 'a method I esteem and whose present aims I consider nothing less than the expulsion of man from itself'.[16] The key point to Breton's definition of Surrealism, at least theoretically, was that human reason should be set aside so that the truth that lay in the undifferentiated unconscious could be laid bare. In Breton's first 'Manifesto of Surrealism' he defined Surrealism as follows:

Psychic automatism in its pure state, by which one proposes to express – verbally, by means of the written word, or in any other manner – the actual functioning of thought. Dictated by thought in the absence of any control exercised by reason, exempt from any aesthetic or moral concern … Surrealism is based on the belief in the superior reality of certain forms of previously neglected association, in the omnipotence of dream, in the disinterested play of thought. It tends to ruin once and for all all other psychic mechanisms and to substitute itself for them in solving all the principal problems of life.[17]

This highly idealistic view of what Surrealism could accomplish seemed to suggest that reasoned thought got in the way of reconciling opposites, that in the unconscious and in dreams (which Breton believed issued directly from the unconscious) a new reality could be found that would solve the world's problems. Whether all the artists and poets who belonged to the movement believed in this is doubtful. But they did believe that the use of psychoanalytical techniques could tap into the unconscious and help create new and strangely beautiful images.

The two main areas of interest for the Surrealists were automatic writing and dream imagery. Automatic writing was practised early on by several of the writers and poets attached to the movement; later the idea was taken up by artists. The two who were most interested in automatic practices were Joan Miró and André Masson (1896–1987). The idea was to somehow disengage the rational conscious mind and allow one's unconscious ideas to come to the surface. The marks produced would be a seismograph of the unconscious. This was the theory. In practice, as several leading Surrealists pointed out, works of art, such as paintings, had to have a formal structure and coherence. This could only be achieved by conscious control. Miró's paintings of the mid-1920s, with their all-over washes of paint on which marks, words and the occasional incipient image are scrawled, were once thought to be largely automatic works. But research has shown that they were carefully made using drawings in Miró's notebooks. The drawings may have been made automatically but the paintings were conscious constructs. Miró was carefully choosing drawings that worked formally but also ones that conformed to his idea of what the unconscious should be, that had interest for him. A painting such as *Maternity* (*Maternité*) 1924 [], is not semi-automatic, in the above sense, but pictographic. Its schematic depiction of a mother with two babies, one male and one female, suckling at her breasts, is a classic Freudian subject (as well as a time-honoured motif). The painting looks forward to the way Miró was later to play around with forms emerging from an undifferentiated flux of colour, but it still relies on conscious abstraction rather than free form.

The imagery of dreams, and, in particular, the way that dreams could bring together objects and events from different times and places in an often disquieting way, had a greater impact on surrealist art than even automatism. Painters and collagists, in particular, loved the way that dreams had the feel of hallucinatory realism, but whose reality was often totally lacking in logic. This collision of realities inspired artists as diverse as Max Ernst, René Magritte and Paul Delvaux. Max Ernst, who was well versed in Freud's ideas, often used dream imagery to explore themes such as the Oedipus complex. In the painting *Max Ernst Showing a Young Girl the Head of his Father* (*Max Ernst montrant à une jeune fille la téte de son père*) 1926–7 [] he alludes openly to the bitter and deadly rivalry between son and father and sets the scene against a backdrop of a forest reminiscent of Böcklin's *Island of the Dead*, 1880. Paul Delvaux's female nudes, sometimes inhabiting an eerily quiet street or railway station, sometimes

18. Salvador Dalí, *La Conquête de l'irrationel* (1935), in *Collected Writings*, p.267.

a wood or, as in *The Call of the Night* (*L'Appel de la nuit*), 1938 [], standing in a skull-strewn wasteland, seem oblivious to their public surroundings: classic inhabitants of dream landscapes. René Magritte's images, with their incongruous juxtapositions, are much more unsettling: a sky where the clouds have been replaced by a female torso, a tuba and a chair – *Threatening Weather*, 1929; the bust of a woman whose head has been replaced by a skull – *The Bungler* (*La Gâcheuse*), 1935 []; the mid-section of a woman framed to follow her curved outline – *Representation* (*La Représentation*), 1937 []. Magritte's deadpan realism places the whole focus on what is depicted, almost as if the images were taken from a children's encyclopaedia. Indeed, in several works, Magritte plays linguistic tricks with what is depicted. In *The Magic Mirror* (*Le Miroir magique*), 1929, for example, a mirror is labelled 'human body'. In the famous work *The Treachery of Images*, 1928, a painting of a pipe is captioned 'This is not a pipe.' In a strict sense, this is true, because it is a painting of a pipe not an actual pipe, but a cursory reading of the work suggests that it is a piece of nonsense. Magritte liked to play around with the relationship between images and works. There is no reason other than history and convention why an object has one name for it and not another. Our cut-and-dried, rationalist world ordains that it is so, for the sake of comprehensibility, but in dreams the situation could be totally different with objects changing their identity to suit new configurations.

Salvador Dalí's paintings, drawings and prints look as if they were dream-related, but, in fact, they owe their irrational juxtapositions and hallucinatory quality to another source, also in psychoanalysis: what Dalí called the 'paranoiac-critical method'. His 1935 definition of the term is highly technical and shows a detailed knowledge of psychoanalysis: 'Paranoia: delirium of interpretive association entailing a systematic structure. Paranoiac-Critical Activity: spontaneous method of irrational knowledge based upon the interpretive-critical association of delirious phenomena.'[18]

Unlike dreams, the delirium of a paranoiac does not have to be interpreted. Elsewhere Dalí quotes from the French psychoanalyst Jacques Lacan (1901–1981) (soon to be famous for his theories about the mirror stage of childhood development) to the effect that the paranoiac delirium comes straight from the unconscious to the conscious mind without being condensed, substituted and displaced as dream images are. The delirium makes rational sense in the context of the paranoiac's inner conflict, even if it seems irrational to us. In that respect the paranoic has already 'intrepreted' reality for us, but according to his/her own paranoia. Dalí uses this interpretative method to deconstruct images of things that, for some reason or other, have obsessed him. The image that perhaps had the greatest impact on him was Jean-François Millet's (1814–1875) famous painting *The Angelus*, 1858–9, which shows two peasants stopping work in the fields to pray as they hear the angelus bell rung in a nearby church. Dalí, so he maintained, allowed his unconscious mind to be stimulated by this image into producing a veritable delirium of scenarios based on the conviction that

19. Sigmund Freud, 'Beyond the Pleasure Principle' (1920), reprinted in Sigmund Freud, *The Essentials of Psycho-Analysis*, Harmondsworth, 1986, p.259.

20. Georges Bataille, *Sur Nietzsche (On Nietzsche)*, Paris, 1945.

21. Gilles Deleuze, *Nietzsche et la philosophie*, Paris, 1962; translated by Hugh Tomlinson as *Nietzsche and Philosophy*, London, 1983.

behind the tranquil scene of peasant piety lies a pent-up relationship of erotic frenzy. In his important series of prints to accompany a special edition of Lautréamont's *Les Chants de Maldoror*, 1934, Dalí juxtaposes images clearly derived from Millet's *The Angelus* with images of the orgiastic, mutually cannibalistic coupling of two Arcimboldesque bony figures – one male and one female. At times the two strands in the series of prints come close together, suggesting that there is more to the peasant couple than meets the eye. The scenes of sadistic cruelty that appear in Dalí's *Maldoror* prints and elsewhere in his art, the breaking down of the human body, are echoes of Nietzsche's vision of the dismemberment of the god Dionysus by the Titans: a dismemberment that Nietzsche sees as symbolic of human individuation, of man's violent separation from nature. Freud has taken this primal experience to be that of birth, of the child being separated from its mother, and the gradual psychological awareness that it is an individual. The way that the figures in Dalí's *Maldoror* prints and in his famous painting *Autumn Cannibalism*, 1936–7, devour each other seems to refer to a stage in the early development of the child. In *Beyond the Pleasure Principle* (1920) Freud says: 'During the oral stage of organisation of the libido the act of attaining erotic mastery over an object coincides with that object's destruction.'[19]

Dalí's frequent references in his works to sadistic practices align him with the ideas of Georges Bataille (1897–1962), who was close to the surrealist movement, but who differed quite radically in certain respects from André Breton, the acknowledged leader of the movement. Bataille, unlike Breton, opposed all attempts to impose an intellectual structure on nature, to make definitions and to put things into neat categories: what Bataille called 'mathematical frock coats'. He proposed the loose idea of '*informe*', of formlessness, where structures are broken down in a process of decay and putrefaction. This was a very similar process to that observed in many of Dalí's paintings. And the concept of formlessness is also close to Nietzsche's vision of universal chaos. Indeed, Nietzsche was a thinker much admired by Bataille and someone he wrote a book on.[20]

Bataille's blacker view of life and nature, his belief in the 'base materialism' (or *bassesse*) of all matter, appealed not only to certain surrealist artists such as Salvador Dalí and André Masson but to a much later generation of writers and artists. Interest in Bataille's work increased in the mid-1970s after the publication of his complete works. This was also helped by the growing importance, particularly in French post-structuralist thought, that thinkers were giving to the work of Nietzsche. In 1962 the French philosopher Gilles Deleuze (1925–1995) published *Nietzsche et la philosophie (Nietzsche and Philosophy)*,[21] a major landmark in post-structuralism, showing the way that Nietzsche's ideas could radically challenge the supremacy of dialectical thought and leading the way to a major rehabilitation of Nietzsche as a 'serious' philosopher not only in France, but elsewhere in Europe and North America. The growing interest in the work of Bataille, Nietzsche and Freud in the 1970s and beyond was a sign

that rationalism (French, in particular) was under attack. Writers such as Jacques Lacan and Julia Kristeva made psychoanalytical concepts central not only to philosophy, but to many other intellectual disciplines and, of course, to the arts. This coincided (not by accident) with a renewed interest in Dada and Surrealism. There had been a flurry of interest in Surrealism immediately after the Second World War, especially around the time of the International Surrealist Exhibition in 1947 at the Galerie Maeght in Paris, when the Surrealists and their leader, André Breton, were still alive and active. Dada had enjoyed a new popularity in Europe and America in the 1950s and 1960s with the emergence of neo-Dada and Fluxus. However, in the context of the overwhelming acceptance of formalist values in art, especially the visual arts, in the first three decades after the War, it became difficult to see how Dada and Surrealism fitted into the accepted paradigm. Only when the number of dissenting voices became really noticeable in the later 1970s and 1980s did artistic and academic interest in Dada and Surrealism really take off.

One of the first serious exhibitions to examine all the ramifications of Dada and Surrealism came in London in 1978 with the Hayward Gallery's, monumental exhibition, *Dada and Surrealism Reviewed*, which looked at the two related movements in the context of the magazines that lay at their core. This was followed up by a highly influential show, *L'Amour Fou: Photography and Surrealism* in 1985, organised by the Corcoran Gallery of Art in Washington (travelling on to the Hayward Gallery in 1986). The catalogue to the show had several ground-breaking essays on the subject by Rosalind Krauss, Dawn Ades (who had curated *Dada and Surrealism Reviewed*) and Jane Livingston. Krauss's essays, in particular, which analyse Breton's central concept of Surrealism, 'convulsive beauty', Bataille's twin concepts of the '*informe*' (formlessness) and 'base materialism', and Freud's idea of 'the uncanny', and relate them to surrealist photography, were important not only to academics, but to artists as well. The photographs by Man Ray (1890–1976), Jacques-André Boiffard (1902–1961), Raoul Ubac (1910–1985), George Brassaï (1899–1984), Hans Bellmer and Claude Cahun (1894–1954) were a revelation to many people. The way, in particular, that the human body was photographed often close up and from unusual angles and even eaten up by its surroundings, subverted conventional, classical beauty and made it strange and unsettling.

Both of Krauss's essays had been published previously in *October* magazine ('The Photographic Conditions of Surrealism' in 1981 and 'Corpus Delicti' in 1985). She also published a key essay on Alberto Giacometti (1901–1966) in the exhibition catalogue *Primitivism in 20th Century Art: The Affinity of the Tribal and the Modern* (Museum of Modern Art, New York) in 1984. Krauss was a key figure in introducing the ideas of Bataille not only to English-speaking audiences in the 1980s and 1990s, but to the visual arts in general, through her readings of Surrealism. Krauss adhered closely to Bataille's notion of the formless as a way of breaking down categories, of opposing conventional, rational views of the world. When Bataille had talked about

aspects of life that were formless like spittle, mud, putrefaction or death, he was simply giving examples of aspects of life that were usually hidden from view as repellent and abject. His decision to include photographs of dead animals in slaughterhouses, of dead flies, of close-ups of the mouth and the big toe was not because he wanted to replace the conventionally beautiful with what was considered base and repugnant, but to subvert our normal way of looking at the world.

This was in contradistinction to the concept of the 'abject' as defined by the writer Julia Kristeva. Kristeva's work, founded in linguistics and psychoanalysis, was much more concerned with probing the psychological source of our horror of the abject, rather than seeing it, as Bataille did, as a tool to attack humanism and rationalism. In her book *Powers of Horror: An Essay on Abjection* (first published in French in 1980) she locates the repugnance (and attraction) we feel for the abject in early childhood memories of separation from the mother, of expulsion from the womb, of the bodily expulsion of faeces and urine and being withheld from sucking at the breast by the mother. Kristeva wants to explain our repugnance for filth, vomit and things like the skin on the surface of milk. She insists on the power of these abject aspects of life and was to be highly influential on the visual arts in the 1980s and 1990s.

In her essay 'Corpus Delicti' Krauss talked about the 'uncanny' and how it related to surrealist photography. Drawing on the work of Freud and his view that what makes things uncanny is the way that they remind us of something that was once familiar and with which we felt at home, but which had undergone a change and was no longer immediately recognisable. Dolls, automata, mannequins and robots all have an uncanny fascination for us. Hal Foster, also linked to *October* magazine, wrote a book called *Compulsive Beauty* (1993) which defined the uncanny (and, its concomitant, the death principle) as at the very core of Surrealism. But he also stresses the importance of trauma in causing a return of dark memories, a compulsive repetition. In a later book, *The Return of the Real: The Avant-Garde at the End of the Century* (1996), Foster uses the idea of trauma and of compulsive repetition to examine the reason why so many artists since the 1960s have returned not just to depicting reality, but to using it directly in their work. For many artists the things which drew them back again and again were objects of abjection, frequently connected with the human body. Foster is closer to Kristeva in the way he views abjection; Krauss is closer to Bataille.

Theory, whether psychoanalytical (Freud, Lacan, Kristeva), surrealist (Breton, Bataille), Marxist, feminist, queer, phenomenological or generally post-structural, played an increasingly important role in the development of new artistic ideas from the 1980s onwards, especially in relation to the human body. However, even more important was what artists learned from other artists, and no artist was more influential in the past thirty years than Marcel Duchamp. This was only in part because of the strongly conceptual bias of his work, placing much of the intellectual effort to construct a 'narrative' around a piece onto the viewer. Perhaps of equal

importance was the emphasis that Duchamp placed on the human body in his work. Many of his most iconic works – *Nude Descending a Staircase*, 1912; *Bride*, 1912; *Fountain*, 1917; *The Bride Striped Bare by her Bachelors, Even*, 1915–23; *Box in a suitcase* (*La Boîte-en-valise*), 1935–41 [55]; *Please touch* (*Prière de Toucher*), 1947 [56]; *Female Fig Leaf* (*Feuille de vigne femelle*), 1950 [49]; *Objet-Dard*, 1951; *Wedge of Chastity* (*Coin de chasteté*), 1954 [46]; *Étant donnés*, 1946–66 – are all concerned with the human body as an erotic and specifically physical entity. For an artist who gave so much importance to the cerebral aspect of art he also paid extraordinary attention to sex. Duchamp's explorations of the (mainly female) body range from his early cubist-inspired paintings, through his readymades, the 'Large Glass', and biomorphic bronzes, to life-like, three-dimensional 'casts'. There are few artists dealing with the human body over the past forty years who have not been influenced by some aspect of Duchamp's work. Louise Bourgeois's biomorphic sculptures, with their often highly sexual connotations owe much to the surrealist tradition of organic, humanoid shapes found not only in Duchamp's bronzes of the 1950s, but in the work of Miró, Yves Tanguy (1900–1955) and the early Giacometti (1901–1966). Like the Surrealists, Bourgeois was intensely aware of the psychoanalytical theories of Freud and especially of Melanie Klein (1882–1960) and her work on children. Bourgeois was in analysis when she lived in New York, helping her to clarify her complex relationship with her father and mother. Much of her sculpture emanates from her love/hate relationship with her father, her attempts to come to terms with her 'penis envy', her envy of masculine power, but at the same time her assertion of the virtues of her femaleness. This ambivalence takes on tangible form in many of her most famous works such as *Janus Fleuri*, 1968, whose twin bulbous forms can be read both as breasts and as penises. The name of the sculpture *Fillette*, 1968–99 [47], suggests the innocence of a young girl, but its uncompromisingly phallic form is aggressively male (although the testis-like shapes at its base can also be read as breasts). Bourgeois saw her work as a reparation of psychological wounds suffered as a child. She once said: 'For me sculpture is the body. My body is my sculpture.' For the body is where her deepest fears played out and could be fought.

Robert Gober comes from a very different generation and artistic milieu than Bourgeois. He came to the fore in New York in the early 1980s, a time when appropriation and the art of the object were in fashion. Gober's art was, however, anything but concerned with consumerism, whether as a critique or a celebration. Rooted in deeply personal ideas about birth, childhood, death, sexuality, the AIDS epidemic (then at its height in New York) and religion, Gober's sculptures or objects are made by hand with a dead-pan, totally non-expressive finish that makes their directness all the more brutal and shocking. Gober tends to work in series: children's playpens and cots, constructed at outrageous angles and in strange configurations that merely serve to heighten their prison-like appearance; sinks, urinals and drains that look more like tombstones or stations of the cross than pieces of plumbing and quietly recalling that many of those who died of

AIDS were gay; legs, buttocks and torsos made of wax and rendered all the more uncanny by the addition of candles, drains, musical notation, a mixture of male and female breasts – and real hair. Gober seemed to fit into the contemporary rubric of the uncanny that was much discussed in the 1980s and 1990s. There is certainly an uncanny quality of reality made strange and disquieting in much of his work. The hyper-realism of Duchamp's female nude in *Étant donnés*, certainly informed his use of lifelike human body parts, as it did the work of many artists in the late twentieth century.

The artist Mike Kelley was intrigued enough by the phenomenon of what he called 'mannequin art' in the 1980s and early 1990s to curate an exhibition of *The Uncanny* in 1993 for the Gemeentemuseum in Arnhem, The Netherlands, and to bring it up to date in a follow-up exhibition of the same title at Tate Liverpool in 2004. In his introductory essay to the Liverpool catalogue he refers to the work of Gober and Kiki Smith as being part of a wider movement in the 1980s and specifically 'related to the AIDS epidemic'. He goes on to say: 'The shocking numbers of deaths associated with the disease made it difficult not to see any depiction of the human form (especially one that evoked doubts about whether it was alive or dead) as a kind of memento mori. Only the most kitschy and pop renderings of the body could escape this reading … ' In retrospect, he regarded it as a huge omission that he did not discuss the work included in his 1993 show in the context of AIDS. Indeed, looking back from today's vantage point it is impossible not to read much of the body art of the late twentieth century in terms of this most defining of tragedies.

If the legacy of Surrealism and of Marcel Duchamp informed one major strand of 'body art' in the post-war period, another strand came out of the implications of Abstract Expressionism and, in particular, of the 'action painting' of such artists as Jackson Pollock (1912–1956), Franz Kline (1910–1962), Willem de Kooning (1904–1997) and Joan Mitchell (1925–1992). Harold Rosenberg (1906–1978) in his 1952 essay 'The American Action Painters' famously defined the canvases of these artists as 'an arena in which to act'. By placing the emphasis on the existential process of painting rather than on the end product, as Greenberg (1909–1994) had done, Rosenberg highlighted the importance of the body and of bodily movement (the intimate connection especially between the unconscious mind and the body) in this type of art. As such, action painting drew on a growing interest in the psychoanalytical theories of Freud and Jung about the unconscious mind's ability to tap directly into archetypal language; and also in Surrealism's early obsession with automatic writing and drawing.

This new interest in body movement was to lead in several directions. In France it led to Yves Klein's (1928–1962) 'anthropométries' for which he applied an intense blue paint (so called 'International Yves Klein Blue') to nude female bodies and choreographed their movements so that their forms were imprinted on specially prepared canvases. In Vienna, the Actionists, Günter Brus, Otto Mühl (born 1925), Hermann Nitsch (born 1938), Alfons Schilling (born

1934) and Rudolf Schwarzkogler (1940–1969), began as action painters, but as the 1960s progressed, they created art using their own bodies, so called 'actions'. These were choreographed beforehand; sometimes the individual artist 'performed' on his own, sometimes with other people; sometimes the artist simply choreographed the event, using other people to 'perform' the action. Brus's actions were an attempt to become part of an extended, three-dimensional and sequential event, often painting himself with white and black paint. Brus presented himself as a suffering, martyred figure, although frequently the harm was self-inflicted. He of all the Actionists came closest to continuing the tradition of Viennese Expressionism, as exemplified by the work of Oskar Kokoschka (1886–1980), Egon Schiele (1890–1918) and Richard Gerstl (1883–1908), where the naked human body was used to express the existential angst of the isolated individual. Mühl, on the other hand, was more concerned to create primal scenarios, with naked 'performers' being covered with various liquids and materials. In these scenes of degradation and abjection Mühl draws on psychoanalytical theory and the ideas of sexual liberation, which became increasingly popular in the 1960s. His type of grotesque actions looks forward to the performance scene of Los Angeles in the 1970s and 1980s and, in particular, to the work of Paul McCarthy and Mike Kelley. Nitsch's actions have an altogether more mythic quality, amalgamating Christian iconography, Nietzsche's ideas about Dionysian rites and Jung's theories of abreaction. Nitsch used red paint, animal blood, dead animals, naked human beings and Catholic vestments to create a rich and heady mixture which had the character of a pagan rite.

The way the Viennese Actionists developed their perfomative art out of 'action painting' had parallels with some of the 'Happenings' that took place in New York in the 1950s and 1960s, with the work of Carolee Schneemann (born 1939), especially her key work, *Meat Joy*, 1964, and, as previously mentioned, the performances of Mike Kelley and Paul McCarthy. However, one of the most significant artists to emerge out of the aftermath of Abstract Expressionism, Bruce Nauman took performative and body art in a completely different direction. There is no attempt at self-expression or self-abandonment in any of his work. Quite the contrary: his work is always cool and carefully considered. The exploration of simple bodily actions, such as walking in various prescribed ways, in prescribed routes around his studio or sometimes along a specially built wooden corridor, takes much from the 'new' dance movements of Merce Cunningham (1919–2009), Yvonne Rainer (born 1934) and especially Meredith Monk (born 1942); but there is always a linguistic edge to Nauman's work. The performances are carrying out very specific instructions; the still photographs of himself bound by rope or of feet covered with clay are literal equivalents in visual form of everyday metaphors: *Bound to Fail* and *Feet of Clay*. Even the sculptures of body parts are literal in the extreme. *From Hand to Mouth*, 1967, is made from a cast of his wife's right arm and the lower right-hand side of her face and neck: literally from hand to mouth. Some critics saw this concentration on bodily actions and body parts as reflecting

22. Bruce Nauman in an interview with Willoughby Sharp, 1970, in Kraynak 1999, p.32.
23. Isabelle Graw in conversation with Mike Kelley, in John C. Welchman, Isabelle Graw and Anthony Vidler, *Mike Kelley,* London, 1999, p.32.
24. Ibid., p.39.

25. Sigmund Freud, 'The Uncanny' (1919), in *Sigmund Freud: Collected Papers*, vol. 4, translated and edited by Joan Rivière, New York, 1959, p.399.
26. John C. Welchman (ed.), *Mike Kelley: Interviews, Conversations and Chit-Chat (1986–2004)*, Zurich and Dijon, 2005, p.267.

an interest on Nauman's part in the philosophy of phenomenology and, in particular, the writings of Maurice Merleau-Ponty (1908–1961). Nauman denied this, but acknowledged the importance of Gestalt therapy, which used phenomenological methods to make people more aware of themselves. He also denied that Duchamp was an important influence on his use of word games. Instead, he stressed how much he took from the writings of Ludwig Wittgenstein (1889–1951) and, in particular, his *Philosophical Investigations* (1953). 'That work had a lot to do with the word-game thing.'[22]

Of all the performative, artistic practices that emerged in the post-war period, Bruce Nauman's was the most cerebral and existential. It probed our awareness of our bodies and of basic bodily movements, by placing them in the simplest of linguistic contexts. In this respect Nauman set himself apart from the predominant Nietzschean/Freudian tradition of exploring the relationship between the body and the unconscious mind. Elsewhere on the west coast of America, Mike Kelley and Paul McCarthy were nothing if not visceral in their approach to the body. Kelley consciously opposed the puritanical, anti-visual nature of conceptual art and other movements of the 1960s and 1970s. In an interview with Isabelle Graw, Kelley said:

> For many artists of my generation there was a tendency to think of art as a visual analogue to the written word – but it's not that simple. Written, spoken or read language operates in one manner and visual language operates in another. It has to do with tactility, materiality, presence – all the other carriers of meaning.[23]

Later in the interview Kelley explicitly relates these physical properties of art to sexuality: 'For me, critical interaction has always been about sexual interaction … I'm interested in the ways sexuality is caught up in language games, whether they be visual or linguistic. What is sexuality outside of that?'[24] It is difficult not to read this as an implied critique of Bruce Nauman.

In 2004, in a discussion about his interest in Freud's concept of the uncanny (Freud: '… the uncanny is nothing else than a hidden, familiar thing that has undergone repression and then emerged from it'.[25]) Mike Kelley said that 'A lot of my work from the last six or eight years has been about Repressed Memory Syndrome, which I think has become the new religion.'[26] In a way 'repression' and 'the repressed' is the subject of most of his work going back to the 1970s. The secret memories of childhood, perhaps the most repressed memories of all, surface in Kelley's frequent use of soft toys and rag dolls. These are, on the one hand, subjected to a quasi-scientific, morphological examination in the 1992 exhibition, *Craft Morphology Flow Chart*. In an adjacent room Kelley showed clumps of stuffed animal toys hanging from a complex pulley system, but shown in such a way that the visitor could not see any of the animals' faces with which to empathise. On the walls pristine, abstract, modernist sculptures sprayed out deodorant into the room, as if to take away the smell of the supposedly used, dirty toys. Kelley described his intentions: 'They made the stuffed animals look even more decrepit. You could read the whole installation as a

27. See note 23, p.32.

28. 'There is a big difference between ketchup and blood', interview with Marc Selwyn in *Flash Art*, no.170, Milan, May/June 1993; Rugoff et al, 1996, pp.128–134.

29. Interview with Erika Billeter (translation by present author) in *Mythos and Ritual in der Kunst der siebziger Jahre*, exhibition catalogue, Kunsthaus, Zurich, 1981, p.89.

play on personification and the abject, dirtiness and cleanliness … '[27] The abject, a term used by Georges Bataille (one of Kelley's favourite writers) and Julia Kristeva (as previously discussed), is a function of repression, often of childhood memories. These are suggested in this 1992 installation of Kelley's but are brought out into the open in two photographs of a staged performance, *Manipulating Mass-Produced Idealized Object*, 1990, and *Nostalgic Depiction of the Innocence of Childhood*, 1990. In this performance an adult man and woman, both naked, regress into an anal fantasy of childhood with the use of a number of stuffed animal toys.

In works such as these Kelley comes closest to fellow Los Angeles artist and sometime collaborator Paul McCarthy. McCarthy's performances, both live and later performed solely for videotape, are informed by the ideas of Freud and other psychoanalysts but they are closer to the theatre of the absurd, to Samuel Beckett and Antonin Artaud, than to Viennese Actionism or Nietzsche's Dionysian rites. They are patently grotesque and often funny in the way that B-movie horror films make us laugh at the obvious use of ketchup. What McCarthy is doing is not attempting a ritual catharsis of primal regressive fears and emotions, but an attempt to lay bare the way that contemporary life has been infected by media imagery. His performances are definitely post-pop. As he said in an interview with Marc Selwyn in 1993:

> There was a time when my work has been compared to the Viennese Actionist school, but I always thought there was this whole connection with Pop. The ketchup, the hamburger and also the movie world. I was really fascinated with Hollywood and Hollywood Boulevard … Vienna is not Los Angeles. My work came out of kids' television in Los Angeles. I didn't go through Catholicism and World War II as a teenager, I didn't live in a European environment. People make reference to Viennese art without really questioning the fact that there's a big difference between ketchup and blood. I never thought of my work as shamanistic. My work is more about being a clown than a shaman.[28]

If McCarthy sees his role as that of a clown, then Joseph Beuys was not afraid to assume the role of the shaman. As he said in an interview in 1981:

> Even today there are still 'actions' for which the figure of the shaman seems to be the most appropriate. Admittedly not to look to the past, in the sense that we have to go backwards again, to the time when the shaman had his legitimacy, because that was a totally different spiritual context. But I use the figure in order to express something about the future, by saying that the shaman stood for something that was capable of bringing together both material and spiritual worlds to form a new unity. So, if in our materialist age, we make use of this figure, we do so in order to point the way to the future. So the important thing is that I should slip into the role of the shaman to express a regressive tendency, to go back to the past, back to the womb, but regression in the sense of progression, using myself as a futurologist.[29]

In actions such as *Eurasia*, 1966, *Manresa*, 1966, and *Eurasienstab*, 1967, Beuys consciously invoked the power of the shaman to make spiritual flights to places and regions in order to suggest a better future, where materialism and spiritualism (West and East) could be reunited. In his 'actions' Beuys used his extraordinary powers of personal magnetism, intense concentration and physical endurance to give tangible form to his ideas, especially his 'expanded concept of art'. Art was no longer just something that one hung on the wall like a painting or put on a plinth like a sculpture (although it was these things as well), but the very stuff of life itself, the way people thought, moved and behaved, not only as individuals but as groups and society as a whole. Beuys also used the term 'social sculpture' to describe his view of the creative forces that could be used to shape the growth of society. At its core, this conception of art as simply part of life came out of the implications that artists such as Allan Kaprow (1927–2006) drew from action painting. It became one of the defining features of Happenings and of the Fluxus movement. Beuys was involved with the Fluxus movement in the Rhineland in the early 1960s, taking part in Fluxus concerts and 'actions'. However, Fluxus's neo-Dada spirit of anarchy and nihilism was alien to Beuys's strong sense of spirituality and social mission and he developed the idea of the 'action' in a very different direction. For Beuys, the human body, the language that it spoke through its movements, gestures and very presence, was central to the meaning of his 'actions'. Human development, for so long in the Western world, meant intellectual development. This one-sided approach had cut humanity off from its spiritual side; a more holistic, organic approach was needed. In his 'actions' Beuys sought to teach people how they could reconnect with their spiritual nature, not through intellectual argument but through their bodies.

Beuys's emphasis on the body, and in particular on his own body as an artist, had a major impact on several artists in the late twentieth century. Matthew Barney is the central figure in his *Drawing Restraint* series of works (1987–ongoing) and the *Cremaster* cycle of 1994–2002 []. Like Beuys, Barney is concerned with change and metamorphosis. Beuys had used the metaphor of alchemy to suggest the transformation of individuals and society onto a more spiritual plane. The material he took to represent this transformation was fat, a substance that, when cold, is hard, static and occupies a fixed, three-dimensional space; when warm, it changes shape, becomes dynamic as it flows in all directions and affects all the materials and objects that it comes in contact with. Likewise Barney adopts metaphors of transformation in his work, initially biological (specifically anatomical) and then in the realms of biography, mythology and geology. In his *Drawing Restraint* series he imposes on his body a series of bodily restraints to make the task of drawing increasingly difficult: climbing up a wall using ropes or hanging over the side of a boat. The biological metaphor centres on the athletic model of developing and training muscles through restraint. As muscles encounter restraint they enlarge, break down and, in healing, become stronger. By setting

obstacles in the way of drawing, Barney hopes to make his drawing technique more highly attuned. Metaphorically the idea is to aim for ever greater refinement in all aspects of life.

In *Cremaster* Barney uses the metaphor of the cremaster muscle – the muscle that controls the raising and lowering of the human testes – and the role it plays in the creation of sexual differentiation: when most 'ascended', sexual differentiation is least accentuated; when most 'descended', differentiation is most accentuated. The metaphor is used to explore a whole series of ideas in complex and vivid stories, not only in the films themselves but in the drawings, photographs, sculptures and vitrines that accompany the films. Just as Barney draws on Beuys's idea of metamorphosis for these works, so is he also inspired by Beuys's use of unusual materials (such as felt and fat). Barney uses petroleum jelly in some of his drawings and self-lubricating plastic to frame many of his drawings and in his highly idiosyncratic vitrines.

Another artist who shared Beuys's interest in using unusual materials in his art was Dieter Roth who was also associated for a while with the Fluxus movement. Roth began his career as a constructivist artist in the manner of Max Bill (1908–1994) but on meeting Daniel Spoerri (born 1930) and other New Realist artists, such as Jean Tinguely (1925–1981), in the early 1960s he came into the orbit of neo-Dada and Fluxus. One of his great contributions to this anti-art movement was the use of biodegradable materials, such as chocolate, cheese and yoghurt. Unlike the idealism of Beuys, which informed his use of fat and felt, Roth's leaning was towards an almost nihilistic acceptance of the fate of all things – decay and entropy. He accepted change and transformation not in any optimistic sense, but as what happened to things. Foodstuffs such as chocolate would eventually break down, consumed by insects and their larvae and then by mould. The diaries that he kept obsessively in the form of writing, videos or drawings, the daily accumulation of detritus, form a time-based self-portrait, disintegrating bit by ineluctable bit.

Beuys in a 1964 'action' famously said that 'The silence of Marcel Duchamp is overrated.' He criticised Duchamp for giving up on art and supposedly devoting himself to playing chess (in fact, he spent much of his time secretly working on his last major work, *Étant donnés*). But for many artists over the last twenty years or so both Beuys and Duchamp have been hugely influential in their different ways. Douglas Gordon, for example, cites the importance for him of Beuys's work in Scotland from 1970 onwards at a time when most art in Scotland was still fairly traditional. However, it was Duchamp's example, along with that of Andy Warhol (1928–1987), which proved to have the bigger impact on his work. Gordon is fascinated by the notion of the divided self, a major trope in Scottish writing from James Hogg's (1770–1835) *The Private Memoirs and Confession of a Justified Sinner* (1824), through Robert Louis Stevenson's (1850–1894) *The Strange Case of Dr Jekyll and Mr Hyde* (1886) to R.D. Laing's (1927–1989) *The Divided Self: An Existential Study in Sanity and Madness* (1960). Gordon explored this in several works of his, including *A Divided Self I* and

11, 1996, *Confessions of a Justified Sinner*, 1995–6, *Monster*, 1996–7, and *Between Darkness and Light (After William Blake)*, 1977, but he was also fascinated by the way that Duchamp and Warhol had dealt with the male/female divide. Duchamp had created his own female alter ego in the form of Rrose Selavy – a clever pun on the French sentence '*Eros, c'est la vie*' or 'Eros, that's life'. Not only had he done so in words, but he had also dressed up as a woman. His female pseudonym alluded to the fact that beneath all gender differences there was a common life instinct that Freud called Eros (and Jung the Libido) – as opposed to the death instinct. In establishing his own female alter ego Duchamp was not simply being playful and provocative (although these ploys played their part) but making a serious point about hermaphroditism, much as Freud had done. From a different and gay perspective, Andy Warhol had also dressed up as a woman and put on make-up for a series of photographs. Gordon takes up this theme in several works, first, and perhaps most notably, in the multi-layered photographic print *Self-portrait as Kurt Cobain, as Andy Warhol, as Myra Hindley, as Marilyn Monroe*, 1996, where, unshaven and sporting a dark stubbly beard, he wears a loose-fitting blond, female wig: a succinct and witty comment on the fluid nature of human identity.

Race, gender and sexual identity have been key issues for many artists over the last thirty to forty years. In the wake of the American Civil Rights Movement of the 1950s and 1960s, the Women's Liberation Movement and the Gay Liberation Movement in the US, UK and elsewhere, artists have used the human body not only in the form of images but in actual physical form to assert and question their identity. In the early 1970s the African–American artist David Hammons made a series of body prints that showed parts of his body in translucent form on paper – almost as if they were X-rays. By doing this he was making a direct challenge to racial stereotypes and by using various colours for the images, such as blue and green, he was asserting the simple fact that all humans are the same beneath the colour of their skin.

For many women artists one of the principal questions to explore was to what extent female identity was the product of their genes; of sexual differentiation in the early stages of growth; of the various crises and complexes identified by Freud and other psychoanalysts as the female child became aware of sexual differences, particularly vis-à-vis her father; or of socially imposed conditioning, which has become ubiquitous with the mass media and the flood of images brought with them.

Some female artists, such as the Cuban–American Ana Mendieta, celebrated womanhood, viewing the naked female body in connection with the earth and various pre-Columbian mother deities. In performances captured on film she used her own body to explore issues of life, death and identity, ritualistically covering or surrounding it with substances such as blood, gunpowder, soil or rock. Others, such as the photographer Francesca Woodman were more interested in the issue of female subjectivity. Taking photographs of herself or of female friends, Woodman often captured bodies

30. Mary Horlock, 'Between a Rock and a Soft Place', in London 2004, p.34.
31. Ibid., p.36.
32. Ibid., p.37.

in blurred movement or in the process of seeming to discover something about themselves. In one famous photograph from the series *Self-deceit,* 1977–8 [] she shows herself naked, crawling up to a mirror and looking at herself. It is almost as if she were seeing herself for the first time, recognising herself and her body. The image seems to sum up what the psychoanalyst Jacques Lacan meant by his concept of the mirror stage. In his early writings Lacan saw the mirror stage as part of an infant's development when it first recognises its image, and therefore itself as an object that others can see as well. Later, Lacan developed the idea so that it represented a permanent aspect of subjectivity.

The British artist Helen Chadwick was one of a number of female artists in the 1970s and 1980s who explored 'the boundaries between the natural and the cultural and the idea that womanhood and femininity were socially constructed'.[30] In works such as *Ego Geometria Sum*, 1983, *Vanity*, 1986, and *The Oval Court*, 1984–6, Chadwick uses her naked body to explore 'the issue of the female body as the site of desire'.[31] She rejected the idea that she was simply reinforcing the male's objectivisation of women and reproducing images of the male gaze. Chadwick countered: 'I was looking for a vocabulary for desire where I was the subject and the object and the author. I felt that by directly taking all these roles, the normal situation in which the viewer operated as a kind of voyeur broke down.'[32] She later moved away from images of herself as being too gendered and turned to images of the inside of the human body. Works such as *Meat Abstracts*, 1989, *Enfleshlings*, 1989, and *Self-portrait*, 1991 [], reflect a general interest in the 1980s in the 'abject' (witness Cindy Sherman's (born 1954) images of the diseased and putrefying body). But Chadwick was less interested in ideas of degradation than some of her American counterparts and more in breaking down entrenched forms of dualistic Cartesian thinking – male/female, mind/body, etc. In works such as *Piss Flowers 1–12*, 1991 [], she celebrates the beauty of what is generally regarded as a rather disgusting waste product.

Another British artist, Sarah Lucas, continues this challenge to stereotypical thinking about gender differentiation. In her set of photographic *Self-portraits 1990–1998* [] she shows herself in various poses and situations that reverse our expectations of conventional femininity, such as demureness or coy (or even overt) sex appeal. Instead she adopts provocatively male stances and gestures and dresses in a unisex uniform of jeans, jacket and sweater. In the sculptures she has made of stuffed tights, the bodies are definitely female, and provocatively so, flaunting their sexuality and availability. Again, so-called traditional female attributes are transgressed. In her most recent sculpture series called *NUDS* [], Lucas again uses stuffed tights as her medium, but the bulging, tumescent forms that create interlocking non-specific body parts are now neither male nor female; in fact, we are not even sure they are human. Their nearest equivalents are the biomorphic forms of surrealist artists Jean Arp or Yves Tanguy.

Sexual difference plays a role in the Serbian artist Marina Abramović's performance pieces, especially when she worked with Ulay (Uwe Laysiepen, born

33. Sigmund Freud, 'Beyond the Pleasure Principle' (1920), reprinted in Sigmund Freud, *The Essentials of Psycho-Analysis*, Harmondsworth, 1986, p.246.

1943) from 1976 to 1988. However, this was really a function of their different sexes and something they exploited in their iconic performance *Imponderabilia* in 1977 []. In this work they both stood naked facing each other at the entrance to the gallery. There was only enough space for one person to squeeze through. A choice had to be made by those entering: should they choose to face Abramović or Ulay? The work was about gender and sexual differences, but more importantly it was about confronting a deep-seated taboo about the naked human body, especially out of the context of the intimate relationship between two lovers. Indeed, during their period of collaboration Abramović and Ulay dressed and behaved as if they were twins, one female and one male obviously, but part of a greater whole. Abramović was interested in using the body to stress otherness, the physical relationship one has between oneself and other people. By choosing to work with Ulay, she gave visual form to this relationship, made viscerally (and sexually) compelling through their naked bodies. After she and Ulay split up in 1988, Abramović turned more frequently to the subject of death and its relationship with life. In her performances (such as *Cleaning the Mirror #1*, 1995 [], made at the Museum of Modern Art, Oxford) she often uses skeletons and skulls, usually in conjunction with her naked body, to shock us into a physical awareness of the ever presence of death.

Death, of course, is the inevitable end of life, something we usually fear. We tend to put it out of our minds, as something intrusive and inimical to our daily lives. The fact that we say 'daily lives' is telling, as if it is the norm, the thing against which everything is measured. In fact, we are dead for infinitely longer than we are alive. One could say that death really is our home and that life is but a brief sojourn in an alien place. Freud said as much when he wrote in *Beyond the Pleasure Principle* that we may in fact long for our permanent home in what he called 'the death drive'. In a passage of lucid and calm argument Freud reasons thus:

> If we are to take it as a truth that knows no exception that everything living dies for internal reasons – becomes inorganic once again – then we shall be compelled to say that 'the aim of all life is death' and, looking backwards, that inanimate things existed before living ones ... The attributes of life were at some time evoked in inanimate matter by the action of a force of whose nature we can form no conception. It may perhaps have been a process similar in type to that which later caused the development of consciousness in a particular stratum of living matter. The tension which then arose in what had hitherto been an inanimate substance endeavoured to cancel itself out. In this way the first instinct came into being; the instinct to return to the inanimate state.[33]

Life really is from death to death.

The storyteller takes what he tells from experience — his own or that reported by others. And he in turn makes it the experience of those who are listening to his tale.

WALTER BENJAMIN [1]

LUCY ASKEW

FROM DEATH TO DEATH AND OTHER SMALL TALES

Visual artists, like Walter Benjamin's storyteller, have persistently sought to distil and share truths about human experience through their ideas and images. In the twentieth and twenty-first centuries this has been especially profound given the seismic shifts in social and economic structures, driven by the emancipation of women, the civil rights movement, and the impact of world conflicts. With the emergence of psychoanalysis and other related discourses, perceptions about the individual within this increasingly fluid society have been redefined. Against the backdrop of social, philosophical and political upheaval, artists have redirected their gaze from the aesthetic qualities and physical attributes of the human body and have sought instead to explore questions of self. The engagement with the body in the visual arts during this period has therefore been an engagement with the potential of medium, form and idea to unearth subconscious, psychological states and the impulses and functions that drive our identity. The body in this context is not simply a living vessel, but a signifier for the cycles embedded in life, from birth to death.

The title of this exhibition – *From Death to Death and Other Small Tales* – is taken from a work by Joseph Beuys, a 'multiple' in the form of a book the artist appropriated, illustrated with drawings and produced in an edition in 1965.[2] Hinting at the complex narratives that make up human lives that inevitably culminate in mortality, this poetic title suggests the plurality embedded in each life cycle and the remarkable that can be found within the apparently ordinary 'small tales' that make

1. Walter Benjamin, 'The Storyteller' (1936), reproduced in *Illuminations: Walter Benjamin*, London, 1999, p.87.

2. The original source, and the book Beuys chose to illustrate, is a book of prose writing by the Austrian neo-symbolist writer Richard Schaukal, *From Death to Death and Other Small Tales*, first published in 1902.

3. Louise Bourgeois, previously unpublished notes for a lecture, late 1960s, quoted in Bernadac and Obrist 1998, p.76.

up human existence. This exhibition explores this multiplicity and the divergent ways the body has been referenced by modern and contemporary artists in order to interrogate a vast array of concerns encompassing psychology, psychoanalysis, gender, sexuality, feminism, otherness, absence, presence, bodily function, taboos, transgression, gesture, action, sensuality, the erotic, voyeurism, ritual, play, childhood and the uncanny.

Selected from two distinctive collections, the remarkable D.Daskalopoulos Collection and the collection of the Scottish National Gallery of Modern Art, the exhibition traces these many strands through juxtapositions between works created in a range of media and across a broad chronology. Works are displayed in pairings and in groups, as well as several room-sized installations, to establish conversations that are intended to draw out these stories – small and not so small – through which artists have revealed and reflected upon human experience.

Whilst these works are conceptually rigorous, materials and their relationship to making and meaning remain fundamental. In a lecture note written in the late 1960s, around the time that she made the first version of her celebrated work *Fillette (Sweeter Version)*, 1968–99 [], Louise Bourgeois wrote that (in her work):

> Content is a concern with the human body, its aspects, its changes, transformations, what it needs wants and feels – its functions.
>
> What it perceives and undergoes passively, what it performs.
>
> What it feels and what it protects, its habitat.
>
> All these states of being, perceiving, and doing are expressed by the processes that are familiar to us and that have to do with the treatment of materials, pouring, flowing, dripping, oozing out, setting, hardening, coagulating, thawing, expanding, contracting, and the voluntary aspects such as slipping away, advancing, collecting, letting go –[3]

In this passage, Bourgeois brings together the notion of artistic process with the functions of the body and our understanding of how the elements of the natural world, of which the human body is a fundamental part, interact. Bourgeois recognises that physical pulses drive inner desires and vice versa, and this balancing of the corporeal and the emotional is constantly at issue in her work, and in the work of many of the artists represented in this exhibition.

Bourgeois's commentary reflects the critical place of materials in how artists have explored the nature of the human body and behaviour. While some artists have employed media such as fabric and spices to produce sensorial effects, others have engaged unconventional means for more transgressive ends. Substances such as rubber, wax, latex, tomato ketchup and polyurethane have appealed to artists for their malleability, visceral qualities, and the ability to invoke or suggest flux, tactility and the sometimes repellent forms, colours or textures associated with bodily matter. Film and video played a central role in recording performances during the 1960s and 1970s, and have also been used to present

4. Krauss 1993, p.230.

complex, theatrical dramas. The wide range of media in this exhibition attests not only to the wealth of approaches within the broad subject of the body, but also to the extraordinary diversity that is found within modern and contemporary visual art.

Through the eyes of male modernist painters such as Pablo Picasso, Otto Dix, René Magritte and Balthus the female body was frequently dissected and distorted, idealised and objectified. Late in his career, Picasso painted a number of bold, aggressively erotic images of female nudes. *Seated Nude (Nu Assis)*, 1969 [], depicts his last wife, Jacqueline Roque, crouched in a provocative, full-frontal pose. The foreshortened composition draws the viewer's eye to a towered arrangement of dislocated body parts: breasts, torso, belly, genitals, and buttocks. In an analysis of other late works by the artist, art historian Rosalind Krauss has noted that 'the female head submits again and again to the same transformation, as it is recast as phallic signifier, the stand-in – mapped onto the nose and hair of the female face – for the genitals of the absent male'.[4] In *Seated Nude,* the mapping described by Krauss extends to the arrangement of Jacqueline's breasts and torso. Projecting his maleness onto and uniting it with the object of his desire, this painting is not simply a portrait. Rather, Picasso emphatically denies the process of aging and potential loss of virility, through his brush and palette.

Confronting Picasso's nude and others by Dix and Balthus is Sarah Lucas's *Bunny Gets Snookered #10*, 1997 [], in which Lucas challenges this notion of the male gaze by appropriating masculine, vernacular language and by engaging her own wry humour. The sculpture, which depicts an apparently female figure formed from stuffed tights and seated on a chair, was first exhibited in 1997 at Sadie Coles Gallery in London as part of a larger group of similar figures. Surrounding a snooker table – positioned as a symbol of macho masculinity – the drooping, anonymous figures appear passive and powerless. Combined with the reference to Playboy 'bunny girls', the title has a dual meaning: firstly, the snooker term to be cornered, and secondly a slang usage that connotes a more aggressive violation. While the physical limpness of the bunny renders her a helpless victim, without a head and no discernable features, Lucas puts into question the object of male fantasy.

As art historian David Hopkins has explored, the suggestion of rebellion found in Lucas's work, manifested in her subversion of gender roles, as well as her use of found, everyday materials to construct her bunny and other sculptural works, owes much to the strategies used by artists associated with Dada and Surrealism. The legacy of both artistic movements pulses insistently throughout the exhibition. The body within the wider project of Surrealism in particular – related most often to desire, eroticism and the unconscious, and explored frequently through Freudian psychoanalysis – has been a site of controversy and provocation and has led to surrealist methods being taken up and dismantled by successive artists.

The respective positions of Marcel Duchamp and Louise Bourgeois as patriarch and matriarch of twentieth-century art history perhaps epitomise the statements, struggles and reactions motivated

5. Nixon 2005, p.15.

6. Louise Bourgeois quoted in Bernadac and Obrist 1998, p.183.

by the surrealist movement. Even while Bourgeois asserted her distance from male surrealist circles, she simultaneously acknowledged her intimate links to them and to Duchamp, stating, 'Marcel Duchamp could have been my father.'[5]

Bourgeois's *Fillette* (*Sweeter Version*) [47], as with Duchamp's so-called 'erotic objects', *Female Fig Leaf*, 1950/61 [49], and *Wedge of Chastity*, 1954/63 [48], are all partial forms, fragments of bodies, divided from their origin. These works embrace the dichotomy between male and female and the ambiguous push and pull between these two oppositional states. Despite its appearance as an enlarged phallus, bristling with visceral, unsettling textures and hung unapologetically to confront the viewer, Bourgeois's choice of title for *Fillette*, meaning 'little girl' in French, highlights the conflation of masculine and feminine while simultaneously pointing to its vulnerability: '… from a sexual point of view I consider the masculine attributes to be extremely delicate; they're objects that the woman, thus myself, must protect … The word "fillette" is an extremely delicate thing that needs to be protected.'[6]

The talismanic quality of *Fillette* may also be associated with Duchamp's *Wedge of Chastity*, and *Female Fig Leaf*, mysterious objects that, unlike Bourgeois's sculpture, are small enough to hold in one's hand. Duchamp presented *Wedge of Chastity* to his wife, Teeny, as a wedding present, and it travelled with them like a lucky charm, representing their conjugal union in the merging of bronze and dental plastic. *Female Fig Leaf*, a bronze cast of female genitals, previously thought to have been cast from Duchamp's wife, has been attributed more recently by art historians to the processes Duchamp used to create his final work, made in secret over two decades, *Étant donnés,* a voyeuristic tableaux that featured the fabricated model of a naked female body.

The surrealist love of language games, notably championed by Duchamp, but also found in the paintings of Magritte, often focused around the ambiguity of identity or a questioning of self. Magritte's painting *The Magic Mirror*, 1929 [51], invites us to gaze into its looking glass, only to find the literal words '*corps humain*' (human body). Bruce Nauman similarly drew on language as his starting point for a group of works he made during the late 1960s, including the wax object, *Knot in Ear*, 1967 [52]. The cyclical title is playful – the ear is formed from a cast knotted rope – while time and again these works return to physical states of the body.

Defined as the acknowledgement of something familiar made strange when encountered outside its usual frame of reference, the notion of the uncanny as taken up by Sigmund Freud had a profound impact on the development of Surrealism. More recently, in 1993, the American artist Mike Kelley interrogated the subject in an exhibition project, *The Uncanny*, in which he brought together an assortment of objects, artefacts and artworks from a range of sources including mannequins and anatomical models. It featured images of a range of artworks, including Hans Bellmer's relentlessly reconfigured doll, *The Doll* (*La Poupée*), *1933–5* [29]. The articulated limbs of Bellmer's often headless doll could be detached and reattached to form abstracted, partial-figures and, as

7. 'Mona Hatoum by Janine Antoni', interview with the artist, *Bomb Magazine*, issue 63, spring 1998.

well as realising these objects as sculptures, Bellmer took numerous photographs of his doll, dressed in baby-doll shoes and socks and staged in a variety of poses and situations. A selection of these disquieting images appeared in the surrealist journal *Minotaure* in 1934 and Bellmer produced his own publications, including *The Doll* (*Die Puppe*) (1934) and *The Doll's Games* (*Les Jeux de la poupée*) (1949). Like Bellmer's doll, Kelley appropriated objects from the world of childhood in his own work, such as the soft toys, blankets and rag-dolls found in *Transplant*, 1990 [], and *Untitled*, 1990 []. Imbued with an unsettling anthropomorphism and transformed through their arrangement in a gallery, these objects feel frighteningly out of place.

Freud's theories and writings relating to childhood and the subconscious have been exploited by visual artists in many directions. Max Ernst's painting *Max Ernst Showing a Young Girl the Head of his Father*, 1926–7 [], is one of several in which the artist alludes to such ideas. Here, the imagery suggests the oedipal conflict, in which the son seeks to kill his own father. However, this is no simple narrative and Ernst's language of dreams and the subliminal remains inscrutable. Shown opposite in the exhibition, Robert Gober's *X Crib*, 1987 [], exposes nocturnal traumas of childhood, memories of confinement and the stifling mores of his strict Catholic upbringing. Transformed into a cruciform shape, the crib is no longer a place of protection; its bars have formed a prison.

Though altered, Gober's crib retains its human scale and domestic associations. The employment of everyday objects or furniture in artworks to imply human presence, loss, actions or emotions, has been a tactic artists have also used to explore the pathos expressed in the absence of the body. Filled with concrete, the wardrobe used by Doris Salcedo in her untitled sculpture of 1995 [] creates an object of mourning that represents the loss of those who once used it. Another cot, Mona Hatoum's *Marrow*, 1996 [], lies in a state of collapse, without the armature that keeps it standing. The artist has described it as being the marrow without the bone and its semi-translucent orange/brown colour suggests the vital fluids hidden within our bodies that support and maintain life.[7] In this work, Hatoum subverts a thing more commonly associated with birth and living to address the mortal reality of the human body. As well as its form, it is in her use of material – the texture, tone and pliability of the rubber – that she achieves this. Rachel Whiteread has similarly explored meaning through materials, invoking human presence and absence by inviting us to read the traces of what was once there. Bringing together the emotive quality of matter and a concept of sculpture based on negative space, *Slab* (*Plug*), 1994 [], cast from the cavity of a bath, makes visible the interior, unseen air that once held a body.

The suggestion of bodily fluids remains implicit in the work of Hatoum and Whiteread but is made explicit in works by Helen Chadwick and Kiki Smith. Made in the early 1990s, Chadwick's *Piss Flowers 1–12*, 1991 [], and Smith's sculptural work *Shitbody*, 1992 [], each points provocatively to base bodily functions. However, though the titles of both can be

8. Eleanor Heartney, 'Kiki Smith: A view from the inside out', in Heartney et al. 2007, p.197.

9. Helen Chadwick quoted in Geraldine Bedell, 'Show people: Blood and chocolate: Helen Chadwick', *The Independent*, 21 August 1994.

10. Robert Gober quoted in 'Robert Gober: Interview with Richard Flood', Liverpool 1993, p.9.

seen in terms of taboo and transgression, each artist uses the jolt of the vernacular to draw attention to other, more profound ideas. In *Shitbody* and works such as *Basin*, 1990, and *Untitled*, 1992 [42], Smith created sculptures in which cast bodies are dissected and their interiors exposed. Speaking about her work during this period, Smith noted, 'The things I'm deeply attracted to always have a cut in them, they're always somewhat scarred and mangled, and the damage of the scarring is evident. You can see the vulnerability.'[8] Smith's work had a central place in the development and articulation of feminist artistic practices that sought to re-evaluate the art historical canon that had been so dominated by men. The use of the body – and specifically the female body – played a key part in the generation of those debates.

The sculptures that form *Piss Flowers* were made by Chadwick in Canada – she and her boyfriend urinated into snow and the cavities formed by the warm liquid were then cast. The resulting fungal-like flower forms and the protuberances that cover them are highly suggestive, alien and other-worldly, and at odds with the directness of the title that points specifically to their making. Interviewed in 1994, Chadwick noted: 'It may have been mischievous to piss in the snow, but it was damn hard work to end up with the 12 bronzes ... when you're looking at them, I hope you can see the serious as well as the mischievous, transgressive aspect.'[9]

Questions of feminism, the play between gender roles and the limits of taboo and inhibition are all themes explored by Marina Abramović and Robert Gober. Despite their use of different media, working methods and means of production, both artists have produced works that require the audience to engage with often unsettling or uncomfortable actions, imagery and ideas. In *Imponderabilia*, 1977 [58], Abramović implicated her audience directly into her performance, while Gober's environments, such as *Untitled*, 1989 [59–6], channel our inner anxieties through the arrangement of familiar and disparate objects alongside images intended to shock.

In Gober's room installation, the walls are shrouded in black and white wallpaper featuring a pattern of male and female genitalia based on a hand-drawn illustration. The walls are punctured by eight drains and, in the centre of the space, a bag of doughnuts, made by the artist, is placed on a pedestal. Gober engages with processes of making – such as baking – more usually associated with women, while drains have been a recurring motif in the artist's practice, suggesting everyday ablutions and the process of flushing. 'I thought of the drains as metaphors,' Gober has said, 'functioning in the same way as traditional paintings, as a window into another world. However, the world that you enter into through the metaphor of the drain would be something darker and unknown, like an ecological unconscious.'[10] The effect of these individual elements brought together is to draw attention to our own sense of puzzlement and discomfort.

Feelings of unease and awkwardness are probed by Marina Abramović in *Imponderabilia*. In the original performance, Abramović and her partner and collaborator, Ulay, stood naked opposite each other in a doorway at the Galleria Communale d'Arte Moderna, Bologna requiring visitors to walk between

11. Günter Brus, Untitled Statement, 1965, reproduced in Stiles and Selz 1996, p.755.

12. Chrissie Isles, 'Subtle bodies: The invisible films of Ana Mendieta', in Washington 2004, p.208.

them, and to decide whose naked body to confront as they crossed the threshold. Through film, the performance now exists as a recorded, temporal event and our relationship to it therefore shifts to that of observer. Although placed in the role of voyeur, rather than actor, we remain engaged with the feelings of unease palpable in the behaviour of some of those captured on film.

The very act of using the artist's own body, often as both the object and subject of the artwork, was by its nature a provocative aspect of performance art as it developed in North America and Europe in the 1960s and 1970s. In 1965, Günter Brus, a member of the Viennese Actionism group wrote: 'My body is the intention, my body is the event, my body is the result.'[11] In ritualised performances that involved the use of animal blood, Brus and other members of the group subjected their bodies to often disturbing actions that aimed at exploring raw human experience. *Untitled (Ohne Titel)*, 1965 [], records a 'self-painting' action in which the artist painted his whole body, ending with painted wound-like lines that score his face. The photographs that make up this untitled collage show Brus in various highly wrought states. A pen-knife, pins and razor blades attached to the surface only serve to further emphasise the potential of violent self-mutilation.

The Cuban-born American artist Ana Mendieta was aware of the performances of the Viennese Actionists, and was influenced by their use of their own bodies and blood.[12] However, Mendieta's work was inflected by her own feminist position, fused with a powerful connection to the earth and to the singular religious synthesis of indigenous and Catholic practices found in Cuban culture. In *Untitled (Blood Sign #1)*, 1974 [], Mendieta smears blood onto a wall before using it to write the words 'There is a devil inside me', invoking mythology and witchcraft as she states her place as an artist.

In contrast to Mendieta's work in film, the actions that take place in Paul McCarthy's video works are both an exploration and a celebration of physical transgression, often at its most extreme. In *Pirate Party*, 2005 [], the debauched activities of a pirate raid are played out by the artist and other actors. Chocolate sauce, tomato ketchup and prosthetics enhance the grotesque nature of the scenes while simultaneously underlining their obvious artifice. By turns comedic and horrifying, such videos by McCarthy play upon the deep-seated, opposing forces of repulsion and attraction within the human condition.

The explosion of Body Art grew in part out of gestural painting, and Greek artist Stathis Logothetis drew on such tendencies and on movements such as Arte Povera to liberate art from the picture frame. His wall-based works, such as Triptych *(Τρίπτυχ)*, 1972 [] have a physical, bodily presence, and indeed their production derives from a performative practice, in which the artist submerged canvases in the sea, allowing them to dry before creating works from them using his own body. In *Torso*, 1981, the artist bound cloth around himself while seated in a chair, subjecting his body to self-imposed constraint. Works of this type express the tension of physical strain and endurance, but on another level reflect anxieties

provoked by the turbulent political backdrop in Greece during this period.

Political, social, personal and artistic freedom was vital to Joseph Beuys, who performed his life as a total work of art. In his actions, he explored the interconnectedness of everything, bringing together sciences and art, mythology and mysticism through his persona as shaman. The protective qualities of felt and fat found so frequently in Beuys's works such as *Sled*, 1969, draw attention time and again to the vulnerability of the body, where actions and motivations are inextricably linked to the spiritual dimension. The utilitarian, empty shell of Beuys's iconic *Felt Suit* (*Filzanzug*), 1970 [20], evokes both the physical activity of everyday life and the simultaneous persistence of its presence beyond death.

The mythological and the physical come together in William Kentridge's three-part film installation, *Ulisse: ECHO scan slide bottle*, 1998 [50], a work that journeys in and around the human body to explore paradoxical states of weakness and strength. Referencing Homer's *The Odyssey*, Kentridge created the work using film originally produced for a staging of Monteverdi's opera *The Return of Ulysses to his Homeland* (*Il ritorno d'Ulisse in patria*), which reflects upon the heroism yet fundamental human vulnerability of its main protagonist, Ulysses. In the artwork resulting from the opera, Kentridge focuses on the interior and exterior of the human body and the dislocation between these two sites.

The interior world of the body, and in particular the functions and processes of the genes and organs that determine sexuality and reproduction, forms an underlying metaphor within Matthew Barney's epic *Cremaster* cycle, 1994–2002 [14–19]. Through highly complex, multiple narratives, the five films explore the frequently uncertain journey of creation – both bodily and artistic – with all its attempts and trials, successes and failures. Barney himself acts as a protagonist, and in doing so, places the body and presence of the artist as a centrepiece around which the layered stories and images unfold. Combining performance, dance and opera as well as cinematic conventions the multiple endings and beginnings of the cycle unravel any sense of chronology. In the gallery version, all five films are played simultaneously, their sonorous sound tracks blending and merging, and the extraordinary and highly theatrical imagery of the films seen side by side. Accompanying them are five vitrines containing objects associated with the films, focusing on the physical presence of matter as it is explored in the cycle.

The personal and autobiographical have been powerful tools in the work of many artists who have used their own bodies and experiences to express intensely private or intimate emotions. Though manifestly different, works by Tracey Emin and Francesca Woodman focus on such subjective experience. In *Family Suite* [9], a suite of twenty monoprints made by the artist in 1994, Emin explores scenes from her early life growing up in Margate. These portraits, self-portraits and observational images are confessional in tone. Their blurred and scratchy lines, resulting in part from the method of printing, suggest the insubstantial nature and uncertainty of memory, but also stand

13. Alyce Mahon, 'Staging Desire', in *Surrealism: Desire Unbound*, exhibition catalogue, Tate, London, 2007, p.286.

14. Ernesto Neto in conversation with Ralph Rugoff, London, 2010, p.23.

15. Michael Baxandall, *Patterns of Intention*, New Haven and London, 1985, p.60.

in for the scars of recollections that hold a deeply emotional register.

Self-portraiture holds a different resonance in the photographic works of Francesca Woodman, which vacillate between formal composition and the ebb and flow of psychological experience. These photographic studies, made by an artist early in her career, show Woodman crouched beside or hiding behind a mirror. The mirror both invites and resists the viewer, ultimately acting as a barrier to mask the elusive presence of the artist. Woodman's work has drawn comparisons with Surrealism, of which she was aware, and the haunting spaces in which she captures her body as a fragmented, ghostly apparition has much in common with the imaginary and seductive environments of those earlier artists. However, whereas the female body was subjected frequently to the male, disinterested gaze in the work of surrealist and other modernist artists, Woodman's images of herself express a wholly interested yet still ambiguous perception that reaches beyond the realms of space, time and action.

The sculptural installations of Ernesto Neto invite the viewer to experience their own physical presence in space. In *It Happens When the Body is Anatomy of Time*, 2000 [] nylon fabric is stretched across the ceiling and from it leg-like forms drop to spice-filled feet. Moving between them, not only is the audience conscious of the protective quality of these biomorphic forms, but the aroma of the spices has a profoundly physical effect, at once evocative and immersive, that heightens our awareness of all our senses. This sensorial space recalls an environment constructed for the surrealist *Eros* exhibition of 1959 that included a room 'with stalagmite- and stalactite-like forms covered in green velvet, in which the sound of orgasmic sighs … and the fragrance of perfume by Houbigant, aptly called "Flatterie", filled the air'.[13] However, Neto's interests are less about the erotic evocations of space, than, as his title suggests, the body as a vessel through which we order nature. As he has noted: 'I try to create a kind of fantasy of nature, and a hypothesis about the structure of the body. There is in my work this idea that you have been swallowed by the sculpture, and you're inside a complex of body relations.'[14]

For visual artists, the investigation of what it is to be human has been, and remains, a compelling and subjective undertaking; sometimes joyful, sometimes disturbing, sometimes sorrowful, and sometimes playful. The threads that weave their way around and through the galleries of this exhibition are many and varied, frequently intersecting, sometimes producing new strands and folding back and forward through time. Bringing together old and new, it also expresses the complexities of artistic lineage. As the critic Michael Baxandall so wisely commented, the history of influence does not take a single route in one direction. Through the vision of a younger artist, his or her predecessor's work takes on new meaning: 'Arts are provisional games and each time an artist is influenced he rewrites his art's history a little.'[15] The stories that unfold through the works displayed in *From Death to Death and Other Small Tales* are myriad, and enriched and transformed by the conversations that take place between their different voices.

THE EXHIBITION

The plates and installation photographs that follow are a record of the sequence of the exhibition shown at the Scottish National Gallery of Modern Art from 15 December 2012 to 8 September 2013.

1 René Magritte, *Representation* (*La Représentation*), 1937

2 Balthus (Balthasar Klossowski de Rola), *Getting Up* (*Le Lever*), 1955 [left]
Sarah Lucas, *Bunny Gets Snookered #10,* 1997 [right]

3 Otto Dix, *Nude Girl on a Fur* (*Mädchen auf Fell*), 1932

4 Pablo Picasso, *Seated Nude* (*Nu Assis*), 1969

5 Max Ernst, *Max Ernst Showing a Young Girl the Head of his Father*
(*Max Ernst montrant à une jeune fille la tête de son père*), 1926–7

6 Robert Gober, *X Crib*, 1987

7 Robert Gober, *Untitled*, 2000

8 Francesca Woodman, *Self-deceit #5*, 1977–8

9 Tracey Emin
[clockwise, from top left]
Mum Smoking; *Dad*; *No Sleep*;
Carry Myself; *Mum, Paul + Me*; *Sex in the Bathroom*
from *Family Suite*, 1994

10 Robert Gober, *Untitled*, 1991

11 René Magritte, *The Bungler (La Gâcheuse)*, 1935

12 Douglas Gordon, *100 Blind Stars* [selection from series], 2002/3

13 Helen Chadwick, *Self-portrait*, 1991

14 Matthew Barney, *Cremaster Cycle,* installation with five films and five vitrines, 1995

15 Matthew Barney, *Cremaster 1*, production still and vitrine, 1995

16 Matthew Barney, *Cremaster 2*, production still and vitrine, 1999

17 Matthew Barney, *Cremaster 3*, production still and vitrine, 2002

18 Matthew Barney, *Cremaster 4*, production still and vitrine, 1994

19 Matthew Barney, *Cremaster 5*, production still and vitrine, 1997

20 Doris Salcedo, *Untitled*, 1995 [left]
Joseph Beuys, *Felt Suit* (*Filzanzug*), 1970 [right]

21 Helen Chadwick, *Piss Flowers 1–12*, 1991

22 Ernesto Neto, *It Happens When the Body is Anatomy of Time*, 2000

24 Robert Gober, *A Pair of Basinless Sinks*, 1986 [left]
Jean Arp, *Rising up* (*S'élevant*), 1962 [centre]
Marcel Duchamp, *Fountain*, 1917/64 [right]

25 Marcel Duchamp, *Fountain*, 1917/1964

26 Robert Gober, *Untitled*, 2010; *Untitled*, 2010; *Untitled*, 2010

27 Sarah Lucas, *NUD 25*, 2010 [left]
Mike Kelley, *Untitled*, 1990 [right]

28 Mike Kelley, *Untitled*, 1990

29 Hans Bellmer, *The Doll* (*La Poupée*), 1933–5

30 Mona Hatoum, *Marrow*, 1996

31 Mike Kelley, *Transplant*, 1990

32 Marina Abramović, *Cleaning the Mirror #1*, 1995

33 Joseph Beuys, *Two Fräuleins with Shining Bread* (*Zwei Fräuleins mit Leuchtendem Brot*), 1966 [left] and *Food for Thought*, 1977 [right]

34 Dieter Roth, *8 timidly sour self-farts*, 1978

35 Sarah Lucas, *Self-portrait with Fried Eggs,* 1996 from *Self-portraits 1990–1998*

36 Sarah Lucas, *Human Toilet II*, 1996 from *Self-portraits 1990–1998*

37 Boyle Family, *Skin Series no.8*, 1973

38 David Hammons, *Untitled (from Flight Fantasy)*, 1995

39 David Hammons, *Blue Angels (Penises)*, c.1970s

40 David Hammons, *Untitled*, 1975

41 Paul Delvaux, *The Call of the Night* (*L'Appel de la nuit*), 1938

42 Kiki Smith, *Untitled,* 1993 [left] *Basin,* 1990 [centre] and *Shitbody,* 1992 [right]

43 Sue Williams, *Creamy Floral*, 1995

44 Louise Bourgeois, *Anatomy Portfolio* [*nos. 6, 12 and 5*] 1990

45 Bruce Nauman, *Small Butt to Butt,* 1989 [left]
Rachel Whiteread, *Slab* (*Plug*), 1994 [below]

46 Rachel Whiteread, *Untitled*, 2000 [left]
Robert Gober, Dog Bed, 1986–7 [right]

47 Louise Bourgeois, *Fillette (Sweeter Version)*, 1968–99

48 Marcel Duchamp, *Wedge of Chastity* (*Coin de chasteté*), 1954/1963

49 Marcel Duchamp, *Female Fig Leaf* (*Feuille de vigne femelle*), 1950/1961

50 William Kentridge, *Ulisse:* ECHO *scan slide bottle*, 1998

51 René Magritte, *The Magic Mirror* (*Le Miroir magique*), 1929 [left]
Bruce Nauman, *Knot in Ear,* 1967 [right]

52 Bruce Nauman, *Knot in Ear,* 1967

53 Vlassis Caniaris, *Le P'tit M'sieur*, 1961

54 Joan Miró, *Maternity* (*Maternité*), 1924

55 Marcel Duchamp, *Box in a Suitcase* (*La Boîte-en-Valise*), 1935–41 [left]
Francis Picabia, *Girl Born without a Mother* (*Fille née sans mere*), 1916–17 [right]

56 Marcel Duchamp and Andre Breton, *Please Touch* (*Prière de Toucher*), cover of the exhibition catalogue *Le Surréalisme en 1947*, 1947

57 Salvador Dalí, *The Signal of Anguish* (*Le Signal de l'angoisse*), 1932/1936

58 Marina Abramović, *Imponderabilia*, 1977

59 Robert Gober, *Untitled* 1989, installation comprising: *Male and Female Genital Wallpaper*, 1989, *Drain*, 1989–2006 and *Bag of Donuts*, 1989

60 Robert Gober, detail of *Untitled* 1989

61 Robert Gober, detail of *Untitled* 1989

62 Joseph Beuys, *Untitled* (from *Plight*), 1985 [left]
Mike Kelley, *Glorious Wound*, 1986 [right]

63 Stathis Logothetis, *Triptych (Τρίπτυχ)*, 1972

64 Günter Brus, *Untitled (Ohne Titel)*, 1965

65 Ana Mendieta, film stills from *Untitled (Gunpowder Work #2)*, 1980,

66 Ana Mendieta, film stills from *Untitled (Blood Sign #1)*, 1974

67 Exhibition entrance, Scottish National Gallery of Modern Art, with view to Ernesto Neto's
It Happens When the Body is Anatomy of Time, 2000

ARTISTS' BIOGRAPHIES AND LIST OF WORKS

CONTRIBUTORS
Lucy Askew LA
Lauren Logan LL
Elizabeth Manchester EM

Marina Abramović
b.1946

A pioneer of performance art, Marina Abramović uses her body as the subject, object and medium of her work. Born and raised in Belgrade, former Yugoslavia, where her parents were high-ranking military officers in the socialist government, Abramović studied at the Belgrade and Zagreb Art Academies during 1965–72. Her first public performance took place in 1973, testing her physical, mental and emotional limits through pain, exhaustion and danger. Subjecting herself to processes and situations in which she lost control, Abramović often presented herself in states of extreme vulnerability. From 1975 to 1988 she lived and worked with the German performance artist Ulay (Uwe Laysiepen), creating such interventions as *Imponderabilia* in which visitors to a gallery opening passed awkwardly between the artists' naked bodies as they stood facing each other inside a doorway. Other collaborative performances explored the relationships between two bodies through repetitive actions requiring extraordinary stamina, using sound to monitor and relay physical responses to stress. In the mid-1990s Abramović began creating installations with multiple video monitors and projections, in which she performed such rituals as cleaning a human skeleton to evoke notions of healing through a confrontation with the inevitability of death. EM

Imponderabilia, 1977
Performance (90mins) at Galleria Communale d'Arte Moderna, Bologna, 1977
Black and white video projection on DVD with sound, 30 minute loop, dimensions variable, edition of 5 with 2 artist's proofs.
Courtesy of the D.Daskalopoulos Collection

Cleaning the Mirror #1, 1995
Five-channel colour video installation with sound and five television monitors, 284.5 × 62.2 × 48.3 cm, artist's proof 2/2, edition of 3
Courtesy of the D.Daskalopoulos Collection

Jean Arp
1886–1966

An artist and poet, Jean Arp is one of the pioneers of abstraction in two and three dimensions. He was born in Strasbourg, France, to French–German parents and developed a cosmopolitan outlook from an early age, assuming the name Hans when speaking in German. After studying at the Strasbourg School of Arts and Crafts, the Weimar Art School (1905–7) and the Académie Julian in Paris (1908), he spent two years in Weggis, Switzerland, working in isolation. In 1912 he encountered Sonia and Robert Delaunay in Paris, and Kandinsky and the Blue Rider Group in Munich. Returning to Switzerland in 1915, he met the painter and dancer Sophie Taeuber – whom he married in 1922 – and co-founded the Zurich Dada movement in 1916. During these years he developed his personal style of organic and geometric abstraction in assemblage-reliefs and paper collages, experimenting with chance as a force of creation stemming from the unconscious. He began making sculpture in the round in 1930–1, producing curvaceous forms in stone, plaster and bronze derived from human and vegetal structures and energies. A member of Abstraction-Création, Arp insisted that his works should be understood as 'concrete' because of their origins in nature. EM

Rising up (S'élevant), 1962
Marble, 176.5 × 44.5 × 44.5 cm
Scottish National Gallery of Modern Art, Edinburgh, purchased 1971, GMA 1253

Balthus (Balthasar Klossowski de Rola)
1908–2001

Born Balthasar Klossowski in Paris to Polish parents, the painter Balthus is known for creating realist portraits and paintings of the human figure. In particular, Balthus caused controversy with the provocative and often voyeuristic paintings of women and girls that he made throughout his career. Such works are frequently imbued with a dark, unsettling eroticism that has been connected to the themes found in Surrealism. However, although he knew many of the avant-garde artists working in Paris during the middle years of the twentieth century, Balthus set himself apart from any movement or group. His interests lay with old master painting, Italian Renaissance frescoes and the Grand French tradition, and he is known to have drawn inspiration from the work of artists such as Courbet and Caravaggio. Following the Second World War, Balthus designed stage sets and costumes for plays by Albert Camus, and many of his compositions reflect a sense of drama and theatricality. LA

Getting Up (Le Lever), 1955
Oil on canvas, 161 × 130.4 cm
Scottish National Gallery of Modern Art, Edinburgh, purchased 1981, GMA 2311

Matthew Barney
b.1967

Employing a highly complex visual language and a wide range of materials and media, Matthew Barney uses his work to explore the nature of bodily human existence and the inner drives through which we interact with the world around us. Barney grew up in Idaho and studied at Yale University in Connecticut. Although he started out as a medical student, Barney soon moved to the fine arts faculty and, while there, took up film, the medium for which he is now perhaps best known. Shortly after leaving university, Barney received his inaugural solo show, held in Los Angeles in 1991, which gained attention from the artistic community. He went on to receive international recognition for his cycle of five films entitled *Cremaster*, made between 1994 and 2002, in which he starred as well as being their writer and director. The title of these films refers to the muscle responsible for the ascending and descending of the testicles in male anatomy. The works are rich in symbolism and draw on the artist's interest in physical pursuits such as athletics and performance as well as historic narratives. The artist has also created a number of sculptural works and installations around *Cremaster* that bring together objects or elements from the films and which expand upon their apparently disparate, but ever-evolving, set of motifs. In other works, such as *Drawing Restraint*, Barney has tested the physical limits of the human body. Barney's work has been exhibited widely, and in 2010 an exhibition displayed Barney's work alongside that of Joseph Beuys, exploring both commonalities and differences in the work of the two artists. LA

Cremaster 4, 1994
Prosthetic plastic, bridal satin banner, manx tartan, silkscreen laser disk in onionskin sleeve, 91 × 122 × 104 cm, edition 6/10
Colour 35 mm film with sound, running time 42 minutes 16 seconds
Courtesy of the D.Daskalopoulos Collection

Cremaster 1, 1995
Silkscreened video disk, cast polyester, self-lubricating plastic, prosthetic plastic, patent vinyl, 91.4 × 121.9 × 129.5 cm, edition 2/10
Colour 35 mm film with sound, running time 40 minutes 30 seconds
Courtesy of the D.Daskalopoulos Collection

Cremaster 5, 1997
35 mm print, laser disk, polyester, acrylic, velvet, sterling silver, 91.4 × 121.9 × 94 cm, edition 1/10
Colour 35 mm film with sound, running time 54 minutes 30 seconds
Courtesy of the D.Daskalopoulos Collection

Cremaster 2, 1999
Silkscreened digital video disk, nylon, tooled saddle leather, sterling silver, polycarbonate honeycomb, beeswax and acrylic, 104 × 119 × 99 cm, edition 3/10
Colour 35 mm film with sound, running time 79 minutes
Courtesy of the D.Daskalopoulos Collection

Cremaster 3, 2002
Two silkscreened digital video disks, stainless steel, internally lubricated plastic, marble and sterling silver in acrylic vitrine, 110.5 × 119 × 102 cm, edition 3/10
Colour 35mm film with sound, running time 3 hours 1 minute 59 seconds
Courtesy of the D.Daskalopoulos Collection

Hans Bellmer
1902–1975

The German artist Hans Bellmer is known principally for his erotic representations of the female body. After training in engineering in Berlin, Bellmer was inspired by Otto Dix and George Grosz to begin drawing, working as a commercial illustrator during the 1920s. In 1933, disgusted by the rise of fascism in Nazi Germany, he decided to abandon his professional career. That year he began making a series of wooden dolls, whose pubescent appearance was inspired by his recently developed obsessions with his fifteen-year-old cousin, the magic and mystery of childhood and the beautiful automaton Olympia, who features in Jacques Offenbach's opera *The Tales of Hoffman*. Often appearing disturbingly deformed, the *Doll* works represent Bellmer's attempts to create a language for the consciousness of the body expressed through their manipulation and documentation in photographs. In 1938, Bellmer settled in Paris, where he joined the Surrealists, publishing a book of hand-coloured photographs of *The Doll* accompanied by Paul Éluard's prose poems, and illustrating George Bataille's *Story of the Eye* (1946). His intricately detailed drawings show female bodies in a state of fluidity and multiplicity, in which their internal anatomy is opened to the voyeur's desiring gaze. EM

The Doll (La Poupée), 1933–5
Silver gelatine print, 27.7 × 25 cm
Scottish National Gallery of Modern Art, Edinburgh, purchased with assistance from the Patrons of the National Galleries of Scotland, 2003, GMA 4681

Untitled, c.1935–6
Ink and collage on black paper, 24 × 19 cm
Scottish National Gallery of Modern Art, Edinburgh, bequeathed by Gabrielle Keiller 1995, GMA 3943

Untitled (From the Roland Penrose 'Surrealist Album', 1936)
Pencil heightened with white gouache on pink paper, 31.2 × 24 cm
Scottish National Gallery of Modern Art, Edinburgh, purchased with support from the National Heritage Lottery Fund and the Art Fund 1995, GMA 3895

The Doll's Games (Les Jeux de la poupée)
Book published by Les Éditions Premières, 1949, 25 × 19.4 cm
Scottish National Gallery of Modern Art, Edinburgh, purchased with assistance from the Friends of the National Libraries 1999, GMA A33/3/DSL/023

Joseph Beuys
1921–1986

Born in Krefeld, Germany, in 1921, Joseph Beuys first intended to become a doctor. However, after volunteering for military service in 1940, he was wounded several times in combat, resulting in a profound change in his ambitions. In 1946 he enrolled in the Düsseldorf Academy of Art, graduating in 1953, before returning to teach there during 1961–72. Influenced by Fluxus during the early 1960s, Beuys built his practice around his self-mythologising, charismatic persona. Making his life and his work indistinguishable, he became a shaman, passionate educator and political activist, enacting ritualistic performances that emphasised the importance of communication. In his radical erosion of the boundaries of art, he sought to make artworks available to all, creating over 600 inexpensive multiples using such non-traditional materials as felt, fat, beeswax, postcards, glass jars, records and films. Felt was of particular significance to Beuys for its capacity to insulate and warm the body, and he often used found household objects and food in his sculptural objects and environments. His belief that art serves a social purpose and that everyone is an artist combined with an anti-rationalist stance that aimed towards healing through imagination and inspiration. Beuys died in Düsseldorf in 1986. EM

Two Fräuleins with Shining Bread (Zwei Fräuleins mit leuchtendem Brot), 1966
Cardboard, paper, chocolate, painted over in oil paint (Browncross), 72 × 20 × 1.5 cm, from edition of 500 (multiple no.2)
Scottish National Gallery of Modern Art, Edinburgh, purchased with assistance from the Heritage Lottery Fund and the Art Fund 2002, GMA 4541

Felt Suit (Filzanzug), 1970
Felt, sewn, stamped, 170 × 60 cm, edition 90/100 (multiple no.26)
Scottish National Gallery of Modern Art, Edinburgh, purchased with assistance from the Heritage Lottery Fund and the Art Fund 2002, GMA 4552

The Silence (Das Schweigen), 1973
Five reels of Ingmar Bergman's film of the same name (1963), galvanised, reels 4 × 38 cm diameter, edition 31/50 (multiple no.80)
Scottish National Gallery of Modern Art, Edinburgh, purchased with assistance from the Heritage Lottery Fund and the Art Fund 2002, GMA 4574

Food for Thought, 1977
Offset on grey machine-made wove, stamped, with grease spot, 88 × 16.5 cm (multiple no.206)
Scottish National Gallery of Modern Art, Edinburgh, purchased 1980, GMA 2235

Show Your Wound (Zeige deine Wunde), 1977
Photographic negatives, one with two holes and brown paint (Browncross); glass, white glass, iron frame, 107 × 79 × 5 cm, from edition of 28 (multiple no.218)
Scottish National Gallery of Modern Art, Edinburgh, purchased with assistance from the Heritage Lottery Fund and the Art Fund 2002, GMA 4605

Untitled (from Plight), 1985
Felt with red aluminium javelin, felt: 148 × 331 × 41 cm, javelin length: 242 cm
Courtesy of the D.Daskalopoulos Collection

Louise Bourgeois
1911–2010

Over a career spanning more than sixty years, Louise Bourgeois created a unique sculptural language centred on the body. Incorporating aspects of Surrealism, Abstract Expressionism and Minimalism, her innovative practice extended to the use of text, drawing, print-making, installation and sound. Born into a family of tapestry restorers based in Choisy-le-Roi near Paris, in 1938 Bourgeois emigrated to New York with her husband the art historian Robert Goldwater, whose expertise in the field of primitive art influenced her first sculptures representing human figures that she cut, gouged and carved from wood. Over the following decades, Bourgeois developed a vocabulary of abstract bodily forms based on oppositions: of vertical versus horizontal; hard versus soft; single entity versus environment made of assembled elements; finely chiselled and polished marble versus roughly textured plaster and latex. When she returned to figuration in the 1960s, the body was usually headless and/or fragmented, and often ambiguously sexual. Driven by her childhood traumas, filtered through psychoanalysis, and expressing such specifically female experiences as pregnancy, childbearing and mothering, Bourgeois's late works created from stitched and stuffed textiles give visible form to her inner demons in order to exorcise them. EM

Fillette (Sweeter Version), 1968–99
Latex over plaster, 59.6 × 26.6 × 19.6 cm, edition 1/3 with 1 artist's proof
Courtesy of the D.Daskalopoulos Collection

Anatomy, 1990
Portfolio of twelve prints: eleven etchings and one multiple; ten etchings, 49.5 × 35.5 cm; one etching, 63.5 × 45.8 cm; multiple, 28 × 21.5 cm; edition of 44 plus 10
Courtesy of the D.Daskalopoulos Collection

Boyle Family

(Mark Boyle 1934–2005, Joan Hills b.1931, Sebastian Boyle b.1962, Georgia Boyle b.1963)

Mark Boyle was born in Glasgow. During the 1960s he collaborated with his partner Joan Hills in making assemblages of junk and found objects, before moving on to produce replicas of sections of the Earth. Their project 'Journey to the Surface of the Earth' was launched in 1968–9. After being blindfolded, they threw darts at a world map, in order to pinpoint 1,000 areas of the Earth's surface to duplicate. On travelling to a selected site, the Boyles would throw a T-square in the air to select a random area to replicate. In the 1970s their two children (Sebastian and Georgia) assisted in producing these works; together they operated under the name 'Boyle Family'.

The *Skin Series* is based on the same principle, mapping surfaces, but on a microscopic scale. *Skin Series No. 8* is an image of a minute section of skin taken from the inside of Mark Boyle's right elbow. Fourteen such works were made, each area being randomly chosen by throwing darts at a body chart. Each skin section was then frozen and removed. A negative image was taken, then enlarged and recorded on light sensitive paper. *Skin Series* also relates to Boyle Family's works of the 1960s, which used bodily fluids. LL

Skin Series No. 8, 1973
Black and white photograph on hardboard (two sheets joined), 183 × 183.4 cm
Scottish National Gallery of Modern Art, Edinburgh, purchased 1974, GMA 1305

Günter Brus
b.1938

A founding member of the Viennese Actionist group, the Austrian artist Günter Brus is best known for his radical performances. After studying commercial graphic art at the Viennese Academy (1957–60), in 1962 Brus developed his violently gestural painted abstractions into a focus on the act of painting itself. His first self-painting, *Aktion*, was created in 1964 and recorded on camera by the film-maker Kurt Kren. Brus viewed his self-painting as a necessary step in creating a language of physical gesture in which his actions, observed by the camera, simultaneously generated and were the picture. As part of the canvas, his body was subject to various forms of self-mutilation, including dividing himself in two with a line of black paint. After 1967, Brus's performances pushed him to increasingly violent physical and mental extremes. In *Art and Revolution* performed at Vienna University in 1968, Brus publicly urinated, defecated, masturbated and cut himself with a razorblade, leading to his arrest and a six-month prison sentence for degrading the symbols of the State. He moved to Berlin the following year and in 1970 abandoned performance and began developing 'image poems' – expressively drawn and painted images inextricably intertwined with text. EM

Untitled (Ohne Titel), 1965
Mixed media on board mounted on wood, 77 × 77 cm
Scottish National Gallery of Modern Art, Edinburgh, purchased 1987, GMA 3054

Vlassis Caniaris
1928–2011

The influential Greek artist Vlassis Caniaris developed a practice that exploded painting from the picture frame into sculptural and corporeal realms. Using a wide variety of media including plaster, mesh, rags and wire to create assemblages and installations, his work frequently reflected on the human condition. Caniaris originally studied medicine but shifted his focus to fine art in 1950 when he joined the Academy of Fine Arts in Athens. He initially made abstract paintings, but was informed by extended stays in Rome, Paris and Berlin during the 1960s and early 1970s where he experienced the innovations of artists active across Europe and America. In 1974, Caniaris returned permanently to Greece and his work responded to the political turbulence that Greece experienced under military rule from 1967 to 1974. His work incorporated performance and action with a socially and politically engaged agenda. In the early 1970s, Caniaris created a cycle of works that referenced the plight of the many migrant workers moving from south to north Europe. With his work exhibited internationally during the 1970s and 1980s, Caniaris was instrumental in engaging artistic communities in Greece with the activity of those in Europe and beyond. LA

Le P'tit M'sieur, 1961
Mixed media, 110 × 29 × 20 cm
Courtesy of the D.Daskalopoulos Collection

Helen Chadwick
1953–1996

During her short artistic career, Helen Chadwick created several provocative and influential bodies of work. She became interested in feminism while studying art at Brighton Polytechnic (1973–6) and Chelsea School of Art (1976–7), leading to early works combining performance with installation that questioned the status of the female body. During the 1980s she explored feminine identity through autobiography, mathematics, classical mythology and the natural world, using large-format photocopies, photographs and sculpture. Aligning her body both with nature – the landscape, the animal world, decay – and culture – geometry and architecture – she expressed her subjectivity in physical and metaphysical

arenas. From the late 1980s she moved away from overt representation of her body, creating a series of still-life photographs composed of offal, drapery and electric lights at the Victoria and Albert Museum, London. Eleven photographic light boxes collectively entitled *Meat Lamps* employ electrical lights to represent consciousness and enlightenment located in visceral expanses of meat, subverting the traditional mind–body hierarchy as well as normal inside–outside body boundaries. Sensual and analytically cerebral, Chadwick's work combines seduction with repulsion in its destabilising fusion of unconventional materials. Cast from cavities produced by urinating in snow, her *Piss Flowers* present characteristically transgressive transformations. EM

Piss Flowers 1–12, 1991
Bronze, cellulose lacquer and carpet, sculptures approx. 70 × 65 × 65 cm each

Courtesy of the D.Daskalopoulos Collection

Self-portrait, 1991
Photographic transparency, glass, aluminium frame and electric lights, 50.9 × 44.6 × 11.8 cm

Scottish National Gallery of Modern Art, Edinburgh, gift of the Contemporary Art Society through a grant from the Henry Moore Foundation 1996, GMA 4096

Salvador Dalí
1904–1989

The flamboyant Spanish artist Salvador Dalí became internationally famous for his meticulous painting style and charismatic persona. Having been thrown out of art school in Madrid in 1923, he explored various styles before fixing on a Surrealist approach in the late 1920s, influenced by the work of artists such as Joan Miró, a fellow Catalan. By the 1930s, Dalí had become one of the most notorious members of the Surrealist group. His highly detailed style showed off his technical mastery and ability as a draughtsman. He frequently chose subjects of an erotic nature, using double imagery to enhance ideas of mystery and ambiguity. His paintings of the 1930s often include female figures in alien landscapes, biomorphic forms, dislocated bodies and phallic symbols. The eroticism of such works reflected his personal life: in 1929 he had met Gala Eluard, the wife of the Surrealist writer, Paul Eluard. Gala became his muse and object of his desire, and in 1934, Dalí and Gala were married. Dalí broke with the Surrealist Group in 1939, and subsequently settled in the United States. In 1941, he completed his autobiography, *The Secret Life of Salvador Dalí*, an unreliable account in which he wove together fact and fiction. LA

The Signal of Anguish (Le Signal de l'angoisse), c.1932/1936
Oil on wood, 21.8 × 16.2 cm

Scottish National Gallery of Modern Art, Edinburgh, bequeathed by Gabrielle Keiller 1995, GMA 3956

Paul Delvaux
1897–1994

The Belgian painter Paul Delvaux is famous for his paintings of female nudes. The son of a solicitor, Delvaux first studied architecture before he switched to painting at the Académie Royale des Beaux-Arts in Brussels (1916–19). His earliest painting style was expressionistic, influenced by James Ensor and Gustave De Smet. In the early 1930s his discovery of the Spitzner Museum at the Brussels Fair – where he saw a wax model of a woman juxtaposed with a skeleton – was to have a lasting influence on his imagery, leading to his many representations of the sleeping Venus. Encountering the work of Giorgio de Chirico around the same time generated a decisive turning point in his art. From this time on, hallucinatory scenes of railway marshalling yards and ruined Antique cities provide the settings for eroticized female nudes whose hypnotised expressions suggest a dream-like alienation. Combining his fascination with architectural line with his love for such neoclassical masters as Raphael and Ingres, Delvaux reinterpreted the timeless subject of the nude through his own personal form of Surrealism. Clothed male characters from the novels of Jules Verne often feature alongside his delicately rendered female bodies in their ornamental environments. EM

The Call of the Night (L'Appel de la nuit), 1938
Oil on canvas, 110 × 145 cm

Scottish National Gallery of Modern Art, Edinburgh, purchased with assistance from the Heritage Lottery Fund and the Art Fund 1995, GMA 3884

Otto Dix
1891–1969

The German painter and print-maker Otto Dix is known for his satirical portraits of Weimar society and his harshly realistic depictions of the brutality of war. Born into a working-class family in Untermhaus, former East Germany, he entered the Dresden Academy of Applied Arts in 1910. After serving in the German Army during the First World War, he returned to Dresden to study at the Art Academy in 1919, making expressionist paintings and co-founding the Dresden Secession. He met George Grosz in 1920 but rejected Dada, turning instead to the more classical and allegorical forms of representation used by the old masters of the German Renaissance. Responding to Nietzsche's call to celebrate the uglier aspects of human physicality, his scenes of fragmented decomposing bodies in the trenches, and portraits of crippled soldiers, nudes, prostitutes and celebrities from German intellectual circles, stem from an unflinchingly detached gaze, causing him to be heralded as a leading artist of the New Objectivity school during the 1920s. His vision became darker and more romantic in the early 1930s, as he increasingly refined his painting technique, using traditional painting methods to undermine cultural and social ideals in more subtle ways. EM

Nude Girl on a Fur (Mädchen auf Fell), 1932
Tempera and oil on canvas laid on wood, 98.5 × 142.8 cm

Scottish National Gallery of Modern Art, Edinburgh, purchased 1980, GMA 2195

Marcel Duchamp
1887–1968

The father of conceptual art, Marcel Duchamp is one of the most significant artists of the twentieth century. Born in Normandy, France, Duchamp was introduced to the Paris art scene by his brothers Jacques Villon and Raymond Duchamp-Villon. In his early cubist experiments he attempted to create a sense of movement, culminating in the painting that first brought him international acclaim, *Nude Descending a Staircase, No. 2*, 1912. After moving to New York in 1915, he developed a form of mechanical drawing to represent elements of the human body suspended in erotic negotiation in his great unfinished work *The Bride Stripped Bare by her Bachelors Even*, or *The Large Glass*, 1915–23. Non-traditional materials, verbal puns and male–female inversions feature frequently in his subsequent works, as in his most famous ready-made, *Fountain*, 1917 – a urinal rotated from vertical to horizontal – and his photographic self-portrait as a woman, Rrose-Sélavy (1921). During the 1930s and 1940s he collaborated with André Breton in organising exhibitions of surrealist art in Europe. Fascinated by the relationship between positive and negative form, he used fragments of a mould from a cast of his lover's body to create his erotic objects of the early 1950s. EM

Fountain, 1917/1964
Glaze cast-ceramic urinal and paint, 35.6 × 49.1 × 62.6 cm, edition 5/8

Courtesy of the D.Daskalopoulos Collection

The Non-Dada, 1922
Printed brochure with ink inscription, 14 × 11 cm

Scottish National Gallery of Modern Art, Edinburgh, bequeathed by Gabrielle Keiller 1995, GMA 3966

Box in a Suitcase (La Boîte-en-valise), 1935–41
Leather-covered case containing sixty-nine reproductions and miniature replicas of Duchamp's works, and one hand-coloured original, 10 × 38 × 35.7 cm (closed), deluxe edition no. 2/20

Scottish National Gallery of Modern Art, Edinburgh, presented by Gabrielle Keiller 1989, GMA 3472

Please Touch (Prière de Toucher), cover of the exhibition catalogue *Le Surréalisme en 1947*, 1947
Book by André Breton and others, with cover by Marcel Duchamp in moulded rubber and velvet, 24 × 20.5 × 4 cm

Scottish National Gallery of Modern Art, Edinburgh, purchased 1999, GMA A33/3/DSL/019

Female Fig Leaf (Feuille de vigne femelle), 1950/1961
Bronze, 9 × 14 × 12.5 cm

Scottish National Gallery of Modern Art, Edinburgh, bequeathed by Gabrielle Keiller 1995, GMA 3967

Wedge of Chastity (Coin de chasteté), 1954/1963
Bronze and dental plastic, 5.7 × 8.5 × 4.2 cm

Scottish National Gallery of Modern Art, Edinburgh, bequeathed by Gabrielle Keiller 1995, GMA 3968

Tracey Emin
b.1963

Born in 1963 in Croydon, and raised in Margate where her Turkish-Cypriot father ran a hotel, Tracey Emin bases her art on her emotional life. Her expressionistic scratchy drawing and painting style was influenced by Egon Schiele and the German Expressionists whom she encountered while studying at Maidstone College of Art (1983–6) and the Royal College of Art, London (1987–9). A prominent member of the Young British Artists (YBAs), Emin had her first solo exhibition in 1993. Entitled *My Retrospective*, it comprised photographs of her destroyed paintings and relics from her family history. A series of diaristic monoprints produced during the mid to late 1990s depict members of her family, sex scenes and such traumatic events as her rape and abortions. Text – in the form of the artist's stream of consciousness voice narrating events or commenting on them – is a significant part of her oeuvre. It features frequently in her works on paper, appliquéd onto quilts and pieces of furniture, in wall-mounted neon tubing and in artists' books. Emin's celebrity persona is central to her work; in confessional video performances and in photographs she exposes a mixture of raw vulnerability and frank aggression. Emin lives and works in London. EM

Family Suite, 1994
Twenty monoprints, 11.6 × 10.6 cm each

Scottish National Gallery of Modern Art, Edinburgh, purchased with assistance from the Art Fund, the Patrons of the National Galleries of Scotland and the Gibson Bequest 2005, GMA 4784

Individual titles:
1. Mum Smoking
2. Dad
3. No Sleep
4. Sex in the Bathroom
5. Gas Mask
6. Sex Man II
7. Sex Man
8. Mother
9. Me at 10
10. Having Twins
11. Mum, Paul + Me
12. The Prince
13. It's in my Life
14. Death from Above
15. New Teeth
16. Big Dick Small Girl
17. Blood Thing at 10
18. Carry Myself
19. Night Death
20. Night is Never Clear

Max Ernst
1891–1976

Max Ernst was born near Cologne in Germany and he became the leader of the Cologne Dada group in 1919.

He began using collage, an important technique used by the Surrealists which challenged the traditional supremacy of oil paint. In 1922, Ernst moved to Paris where he became a central figure in the surrealist group. Like many surrealist artists, Ernst was interested in the use of chance and automatism to try to produce new images from his unconscious mind. He often used techniques that created unusual and unplanned paint effects.

The precise meanings of many of Ernst's paintings are intentionally obscure. He was far more interested in poetic suggestion, mystery and ambiguity than in literal interpretations.

Ernst's oedipal conflicts with his father are highlighted in many of his works including the large, majestic and savage painting *Max Ernst Showing a Young Girl the Head of his Father*. The title of the painting is ambiguous. The 'young girl' may be Ernst's sister, who died when he was just six, in which case an incestuous triangle of father, son and daughter is implied. The relationship between the sexes is a common theme in Ernst's work. LL

Max Ernst Showing a Young Girl the Head of his Father (Max Ernst montrant à une jeune fille la tête de son père), 1926–7

Oil on canvas, 114.3 × 146.8 cm

Scottish National Gallery of Modern Art, Edinburgh, accepted by HM Government in lieu of Inheritance Tax and allocated to the Scottish National Gallery of Modern Art 1998, GMA 3972

Robert Gober
b.1954

Following studies at Middlebury College in Vermont and a year at the Tyler School of Art in Philadelphia, Gober moved to New York in 1976. There he earned his living by working as an assistant to other artists. In 1984, he was given his first solo exhibition at the Paula Cooper Gallery, and many of the motifs that appeared in this exhibition have remained in Gober's rich and varied vocabulary. Gober explores the potential of domestic objects – often those we take for granted such as doors, drains and basins – to suggest deep-rooted concerns and anxieties in the human psyche. The banality of the objects Gober chooses and his method of undermining their function produce sculptures that have a disquieting presence. Since the 1990s, Gober has also made sculptures of fragmented body parts in wax and hair that are uncanny in their exacting verisimilitude. Single legs projecting from walls, for example, create visual jokes while simultaneously alluding to sexual symbols. Gober has also produced several large-scale installations in which he has brought together disparate objects to create unsettling experiences for the viewer. In these, as in much of his other work, Gober addresses questions of identity. Openly homosexual himself, Gober brings to the fore dual or opposing states such as masculine and feminine, heterosexuality and homosexuality, sacred and profane, erotic and abject. Gober's interest in everyday objects has its roots in Marcel Duchamp's *Readymade*, and his work has also been associated with the work of surrealist artists, both in terms of his use of chance or strange encounters and the suggestive, erotic currents that are subtly at play in his works. LA

A Pair of Basinless Sinks, 1986
Plaster, wood, wire lath, semi-gloss enamel paint, 68.6 × 168.9 × 6.6 cm overall
Courtesy of the D.Daskalopoulos Collection

Dog Bed, 1986–7
Hand-woven rattan, cotton, flannel and fabric paint, 26 × 94 × 74 cm
Courtesy of the D.Daskalopoulos Collection

X Crib, 1987
Wood and enamel paint, 112 × 129 × 85 cm
Courtesy of the D.Daskalopoulos Collection

Untitled, 1988
Silver gelatine print, image: 16 × 24 cm, sheet: 20 × 25 cm
Courtesy of the D.Daskalopoulos Collection

Unfolding Door, 1989
Wood, steel and enamel paint, 85 × 85 × 47 cm
Courtesy of the D.Daskalopoulos Collection

Untitled, 1989
Room installation comprising:

Male and Female Genital Wallpaper, 1989
Hand-printed silkscreen on paper, each roll: 61 × 114 cm

Drain, 1989–2006
Cast pewter, eight parts, each diameter 10.8 × 7.6 cm

Bag of Donuts, 1989
Acid-free hand-cut paper, graphite, dough, synthetic resin, 28 × 17 × 15 cm
Courtesy of the D.Daskalopoulos Collection

Untitled, 1991
Beeswax with hair, pigment, 61 × 40 × 31 cm
Courtesy of the D.Daskalopoulos Collection

Newspaper, 1992
Photolithograph on archival (Mohawk Superfine) paper, twine, 11.4 × 35.5 × 40.6 cm, edition 7/10
Courtesy of the D.Daskalopoulos Collection

Untitled, 1992–6
Photolithograph on folded French duotone paper, 58 × 35 cm, edition 37/40
Courtesy of the D.Daskalopoulos Collection

Untitled, 2000
Lithograph, screen print, mixed media on paper, 55.9 × 81.3 cm, edition 42/47
Courtesy of the D.Daskalopoulos Collection

Untitled, 2002
Four-colour lithograph on arches cover paper, 119 × 81 cm (plate), 130 × 91 cm (sheet), edition 51/65
Courtesy of the D.Daskalopoulos Collection

Untitled, 2010
Plaster, 31 × 26 × 6 cm
Courtesy of the D.Daskalopoulos Collection

Untitled, 2010
Plaster, 42 × 29 × 8 cm
Courtesy of the D.Daskalopoulos Collection

Untitled, 2010
Plaster, 31 × 25 × 8 cm
Courtesy of the D.Daskalopoulos Collection

Douglas Gordon
b.1966

Douglas Gordon is a conceptual artist whose wide-ranging practice encompasses video, film, text, sound, photographic objects and installation. Born in Glasgow into a family of Scottish Calvinists, he pivots his art on the dualities of good and evil and darkness and light that structured his earliest years. After attending Glasgow School of Art (1984–8) and the Slade School of Art, London (1988–90), Gordon made his name with *24 Hour Psycho* – commissioned for Tramway in Glasgow – in 1993. This and other works of the early 1990s manipulated pre-existing film footage and projected it onto large free-standing screens, challenging the construction of meaning through memory, and the viewer's physical and psychological relationship with the moving image. The notion of the doppelgänger is central to Gordon's work, featuring in his video performances, in his reworking of transformational alter-ego moments in such classic films as Rouben Mamoulian's *Dr Jekyll and Mr Hyde*, and in his frequent use of mirrors. For his series of *Blind Stars*, Gordon excised the eyes from photographs of film noir actors and actresses, replacing them with white, black or mirrored board to evoke an unknowable double lying beneath the surface of the glamorous mask. EM

List of Names (Random), 1990–ongoing
Wall text, typeface variable, dimensions variable
Scottish National Gallery of Modern Art, Edinburgh, purchased (Iain Paul Fund) 2000, GMA 4335

100 Blind Stars [selection from series], 2002/3
Black and white photographs with collage, 66 × 61 cm each
Scottish National Gallery of Modern Art, Edinburgh, on loan from the artist
GML 1085

David Hammons
b.1943

An African-American artist whose conceptual practice includes performance, sculpture and installation, David Hammons makes art from deliberately provocative materials. Born and raised in Springfield, Illinois, he moved to Los Angeles in 1962, attending Choinard Art Institute (1966–8) and the Otis Institute (1968–72) before relocating permanently to New York in 1974. Centred in the black urban experience and influenced by jazz, Hammons's Duchampian practice employs verbal puns and word-games to disrupt given relationships between objects and their signifiers. He first gained a reputation for his series of body prints begun in the late 1960s, made by pressing his margarine-coated form to paper that he afterwards dusted with powdered pigment. At times juxtaposed with the American flag, these imprints raise questions of racial stereotypes and national identity. In the late 1970s Hammons began to make sculptural assemblages using Arte Povera elements such as elephant dung, Afro hair, meat bones, greasy paper bags and bottles. In his best-known performance, *Bliz-aard Ball Sale*, 1983, he peddled snowballs on New York's Cooper Square in winter, subverting art's normal channels of production and distribution through his insistence on the extreme ephemerality of his objects and on the street as his central arena. EM

Blue Angels (Penises), c.1970s
Body print, 29.7 × 37.7 cm
Courtesy of the D.Daskalopoulos Collection

Untitled, 1972
Paint pigment on paper, 84.5 × 72.4 × 4.4 cm
Courtesy of the D.Daskalopoulos Collection

The Falling Penis, 1974
Watercolour on paper, 63.5 × 45.7 cm
Courtesy of the D.Daskalopoulos Collection

Untitled, 1974
Body print, 34.3 × 29.2 cm
Courtesy of the D.Daskalopoulos Collection

Untitled, 1975
Body print, 106.7 × 78.7 cm
Courtesy of the D.Daskalopoulos Collection

Untitled (from Flight Fantasy), 1995
Mixed-media installation: paint, custom rollers, heavy metal wire hoops, human hair, crystals and netting, dimensions variable
Courtesy of the D.Daskalopoulos Collection

Mona Hatoum
b.1952

The work of Mona Hatoum stems from the experience of double exile: born in 1952 in Beirut to Palestinian parents, she was visiting London in 1975 when war broke out in Lebanon, preventing her return. After attending the Byam Shaw School of Art (1975–9) and the Slade School of Art (1979–81) in London she began to make work about the experience of cultural displacement. Her early performances focus intensively on her body, using it as a metaphor for political and sexual oppression. Themes of dispossession, displacement, claustrophobia and controlled violence are common. In 1989 she began making sculptural installations using gridded metal structures that suggest fences and cages in combination with elements that bring light and warmth, generating ambiguous combinations of cruelty with comfort. Items of domestic furniture feature frequently in Hatoum's work of the 1990s, selected for their role of providing support for the body. As a symbol of nurturing containment for the vulnerable and dependent, the infant's cot has particularly poignant associations. Hatoum exploits these through her use of such materials as glass tubing, metal wires and latex, transforming a bed into place of torture or potentially lethal structural collapse. EM

Marrow, 1996
Rubber, 129 × 59 × 51 cm
Courtesy of the D.Daskalopoulos Collection

Mike Kelley
1954–2012

Mike Kelley's eclectic conceptual practice encompassed performance, video, drawings, collage, text, assemblage and installation. Embracing the extreme contradictions of the American psyche, he used the forms and visual language of popular culture to undermine history, philosophy, politics, science and religion, inserting them into the discourse of contemporary art. Born in Detroit into a working-class Roman Catholic family, Kelley attended the University of Michigan in Ann Arbor where he co-founded the 'anti-rock' band Destroy All Monsters (1974) with Jim Shaw. In 1976 he moved to Los Angeles to attend Cal Arts, forming another art-band, The Poetics, with Tony Oursler. In 1978 he began creating intense performances using soliloquies and highly charged poetic prose. Soon the props began to feature in installations alongside photographs and drawings in a series of projects exploring philosophical themes that he subverted through counter-culture references. In the mid-1980s, Kelley began working with handcrafted blankets and soft toys, creating figures that suggest abject and vulnerable human characters while simultaneously evoking the monstrous. The motifs of childhood repression and domestic violence reappear in video performances enacting scenes of family dysfunctionality made collaboratively with Paul McCarthy during the 1990s that affirm art's potential as therapy. EM

Glorious Wound, 1986
Acrylic on cotton with wig, 203 × 119 cm
Courtesy of the D.Daskalopoulos Collection

Transplant, 1990
Mixed media, 343 × 77 cm
Courtesy of the D.Daskalopoulos Collection

Empathy Displacement: Humanoid Morphology (2nd & 3rd Remove) #4, 1990
Acrylic on panel and found hand-made doll in painted wooden and glass box, 106.7 × 48.3 cm (panel), 19.7 × 12.7 × 40 cm (box)
Courtesy of the D.Daskalopoulos Collection

Untitled, 1990
Two rag dolls sewn together, 77 × 33 × 8 cm
Courtesy of the D.Daskalopoulos Collection

William Kentridge
b.1955

The South African artist William Kentridge fuses drawing and film to deal metaphorically with colonialism, capitalism, landscape and the body. His work reflects ambiguously on collective complicity in totalitarian regimes, combining satire with poetical lyricism in its treatment of political idealism. Kentridge was born and raised in Johannesburg, attending the local Art Foundation during the 1970s, before going on to study mime and theatre at L'École Internationale Jacques Lecoq, Paris, from 1981 to 1982. He abandoned acting shortly afterwards, but theatre and performance remain crucial to his art. In 1989 he began making animated films that refined the imagery of his prints and drawings of the previous decade. They are based on large drawings in charcoal and pastel successively altered through repeated erasing and redrawing, providing an analogy for the layering of memory and the desire to forget. Processions of walking figures and fragments of bodies feature frequently in the desolate landscape of the Johannesburg mines. In 1997 Kentridge began to mix documentary film footage, photographic stills and moving puppets into his films. Images of bodies morphing into machines or bodies opened to reveal their internal structure allegorise fluid identities and the frailty of the human spirit. EM

Ulisse: ECHO scan slide bottle, 1998
Digital colour and black and white video, transferred from 35 mm film, three-channel projection (scan: 29 minutes, 48 seconds; slide: 30 minutes, 5 seconds; bottle: 31 minutes, 56 seconds – each looped), edition 4/4
Courtesy of the D.Daskalopoulos Collection

Stathis Logothetis
1925–1997

A key figure in the history of contemporary Greek art, Logothetis's practice was embedded in the international avant-garde tendencies of the 1960s that sought to expand painting beyond its traditional structures. Born in Burgas, Bulgaria, Logothetis moved with his family to Thessaloniki in Greece when he was eleven. Although he initially studied music, by 1954 he had taken up painting and had committed to a career as an artist. Through scholarships in 1956 and 1960 and later through the German Academic Exchange Service in 1972–3, Logothetis travelled extensively and became acquainted with artistic communities across Europe. His work has affinities with both the Italian movement Arte Povera – in his use of cheap, everyday materials and emphasis on the relationship between art and life – and with strategies of Body Art and performance – in terms of his transformation of materials through physical actions. By combining these with aspects drawn from Dada and ideas of time and chance, Logothetis shaped a singular, abstracted language that speaks of the tension and constraints of the body. Having settled in Athens in 1973, Logothetis's work featured in many group exhibitions in his homeland and around the world throughout his career. Sadly, his artistic career was cut short in 1987 due to ill-health, but his legacy has remained a vital driver within contemporary art in Greece. LA

Triptych (Τρίπτυχ), 1972
Acrylic on canvas, three parts, each 150 × 75 cm
Courtesy of the D.Daskalopoulos Collection

Sarah Lucas
b.1962

Sarah Lucas is known for her sculptural assemblages employing ordinary objects from everyday life to depict the human body. Born in London and educated

at Goldsmiths College of Art, she is one of the group of YBAs who came to prominence during the early 1990s. She first made her name with a series of sculptures in which basic foodstuffs were combined with clothing and pieces of household furniture to represent bodies bawdily distinguished by their sexual attributes. A series of self-portrait photographs feature similar ingredients: smoking a cigarette or sitting on the toilet, the artist's androgynous appearance creates an ambiguous effect, questioning gender stereotypes and voyeuristic clichés. Extending her range of appropriated materials and casting parts of her body, Lucas has continued to use art to make visual and linguistic jokes about sex in a manner that is both humorous and disturbing. She began working with stuffed tights in the early 1990s, creating a group of abject female mannequins known as 'bunnies' in 1997. Her recent series of NUDS is less obviously gendered and more intestinal, representing a departure from the literal into suggestion and abstraction. Lucas lives and works in Suffolk. EM

Self-portrait with Fried Eggs, 1996
From Self-portraits 1990–1998, 1999
Colour iris print, 74.6 × 51.5 cm (image), 76.1 × 56.1 cm (sheet), edition 34/150 with 15 artist's proofs

Scottish National Gallery of Modern Art, Edinburgh, presented by Sadie Coles HQ 2003, GMA 4679F

Human Toilet II, 1996
From Self-portraits 1990–1998, 1999
Colour iris print, 74 × 49 cm (image), 76.1 × 56.3 cm (sheet), edition 34/150 with 15 artist's proofs

Scottish National Gallery of Modern Art, Edinburgh, presented by Sadie Coles HQ 2003, GMA 4679G

Fighting Fire with Fire, 1996
From Self-portraits 1990–1998, 1999
Colour iris print, 73 × 51.5 cm (image), 76.2 × 55.8 cm (sheet), edition 34/150 with 15 artist's proofs

Scottish National Gallery of Modern Art, Edinburgh, presented by Sadie Coles HQ 2003, GMA 4679H

Bunny Gets Snookered #10, 1997
Tan tights, red stockings, chair, steel clamp, kapok and wire, 104 × 71 × 89 cm

Courtesy of the D.Daskalopoulos Collection

NUD 25, 2010
Tights, fluff, wire, 38 × 36 × 43 cm

Scottish National Gallery of Modern Art, Edinburgh, on loan from a private collection

Paul McCarthy
b.1945

Based in Pasadena, southern California, Paul McCarthy uses performance, film and sculptural installation to critique mainstream American culture and its TV and media obsessions. He was born in Salt Lake City, Utah, and studied painting at the University of Utah, before moving to California in 1968, attending the University of Southern California, Los Angeles, in the early 1970s. His earliest experimental videotapes present unconventional painting actions such as whipping a wall and a window or painting a line on the floor with his head. They quickly became more viscerally challenging, as McCarthy tested his emotional and body boundaries, smearing his naked body with culinary ingredients, forcing food into his mouth until he gagged, and wearing drag. In 1976 he began using masks to ridicule masculine stereotypes, attack traditional American family values and sexual taboos, and transform cutesy Disney characters into monstrous pop icons. Ketchup, mayonnaise, mustard and chocolate all feature as symbols for body fluids, thrown around in a messy gestural send-up of the heroic male abstract expressionist painter. The filmed performance *Pirate Party* was part of McCarthy's *Caribbean Pirates*, 2001–5, created in collaboration with his son Damon McCarthy. The project was inspired by Disney's *Pirates of the Caribbean*. EM

Pirate Party, 2005
(with Damon McCarthy)
Four-channel video, running time 1 hour 32 minutes, edition 3/3

Courtesy of the D.Daskalopoulos Collection

René Magritte
1898–1967

Magritte was born in Belgium and, apart from a few years spent in Paris in the late 1920s, lived there all his life. Unlike Ernst and Miró, Magritte did not believe that the unconscious could express itself through chance or through 'automatic' techniques. He planned his paintings with great rigour and executed them with all the *trompe-l'oeil* skills of a traditional academic painter. The results are surprisingly realistic images of seemingly illogical and dreamlike scenes. Magritte's dead-pan style owed much to Giorgio de Chirico and, like de Chirico, Magritte would undermine the logic of illusionism by tampering with scale and perspective or by placing unrelated objects in unexpected settings.

A constant theme running through Magritte's art is the equivocal relationship that exists between the painted image and the visible world, between what we think of as fiction and reality. Magritte's art blurs the boundaries between the two. The simple expedient of swapping motifs to present an unexpected new form is a recurrent feature of his work. Magritte produced a series of 'word paintings' in the late 1920s in which the words and the image seem to conflict with each other. Painted early in 1937, *Representation* (*La Représentation*) provides an ironic commentary on the whole tradition of illusionism in Western painting, and specifically on that branch of the tradition which provokes desire through the sensual and realistic treatment of the naked body. LL

The Magic Mirror
(Le Miroir magique), 1929
Oil on canvas, 73 × 54.5 cm

Scottish National Gallery of Modern Art, Edinburgh, bequeathed by Gabrielle Keiller 1995, GMA 3997

The Bungler (La Gâcheuse), 1935
Gouache on paper, 20 × 13.6 cm
Scottish National Gallery of Modern Art, Edinburgh, bequeathed by Gabrielle Keiller 1995, GMA 3998

Representation (La Représentation), 1937
Oil on canvas laid on plywood, 48.8 × 44.5 cm (frame 54 × 49.2 cm)
Scottish National Gallery of Modern Art, Edinburgh, purchased 1990, GMA 3546

Ana Mendieta
1948–1985

The art of Cuban-born Ana Mendieta stems from her sense of displacement, the result of having been exiled from her family and homeland during early adolescence by the country's political upheavals. Raised between boarding school and foster homes in Iowa, USA, during the 1960s, she went on to study art at the University of Iowa (1967–77). There, on the innovative Intermedia programme run by Hans Breder, Mendieta developed a personal fusion of performance and land art that she termed 'earth-body work' and 'earth-body sculpture', resulting in many of the iconic works for which she is known today. Influenced by Viennese Actionism, Mendieta employed blood for its magical properties as a symbol of birth and renewal in ritualistic performances that combine the culture of Cuban Afro-Caribbean Santeria rituals with Catholic symbolism. For her *Silueta* series, created between 1973 and 1980 in Iowa and Mexico, Mendieta's supine body was covered in flowers, leaves or sticks, or it was outlined in the earth to create a silhouette filled with water, blood, stones, candles, gunpowder or fire. For Mendieta, making art was a return to the maternal source, her means of re-establishing the bonds that connect her with the universe. EM

Untitled (Blood Sign #1), 1974
Super-8 colour, silent film transferred to DVD, running time 4 minutes 40 seconds, edition 4/6
Courtesy of the D.Daskalopoulos Collection

Untitled (Gunpowder Work #2), 1980
Super-8 colour, silent film transferred to DVD, running time 3 minutes 51 seconds, edition 2/6
Courtesy of the D.Daskalopoulos Collection

Joan Miró
1893–1983

Miró was born in Barcelona and moved to Paris in 1920. In Paris he abandoned Cubism and began to paint an imaginary world full of strange, insect-like figures floating in space. This fantastic sign language, which was partly inspired by dreams, soon became a hallmark of surrealist art. The transformation took place in 1924 and may be seen in several of Miró's paintings of that period. In August 1924 Miró wrote to a friend saying 'My latest canvases are conceived like a bolt from the blue, absolutely detached from the outer world (the world of men who have two eyes in the space below the forehead).'

The motifs in Miró's paintings became drastically simplified. However, the imagery in his painting *Maternity* can be traced to a specific source: a postcard of a seated Spanish dancer wearing a décolleté dress. In two large drawings in coloured chalk on canvas and several small pencil sketches, Miró reduced the dancer's head and neck to a black, keyhole shape, connected by a thin vertical line to a triangular body. The body of the mother in *Maternity* is punctured by a large hole which echoes the polka-dot motif of the dancer's dress. One of her breasts in shown in profile, the other from the front. Two insect-like infants, one male, the other female, are suspended from their mother's breasts. LL

Maternity (Maternité), 1924
Oil on canvas, 92.1 × 73.1 cm
Scottish National Gallery of Modern Art, Edinburgh, purchased with assistance from the National Heritage Memorial Fund, the Art Fund (William Leng Bequest) and members of the public 1991, GMA 3589

Bruce Nauman
b.1941

One of the most influential artists of his generation, Bruce Nauman is known for his pioneering work in sculpture, performance, installation and sound art. Born in Fort Wayne, Indiana, in 1941, he studied mathematics and art at the University of Wisconsin before attending the University of California at Davis (1965–6). Here he began a series of experimental works in which he documented repetitive physical actions and manipulations in the studio using photography and videotape. At the same time he made sculptures moulded from parts of his body, employing linguistic puns that recall the conceptual word-play of Marcel Duchamp. After constructing corridors and room-sized environments that involve the visitor in experiences of claustrophobia and exposure during the 1970s, Nauman returned to the fragmented body in the 1980s with hanging sculptures made from taxidermic moulds of animals, following these with casts of human heads and hands. He frequently employed structural tactics of doubling and mirroring around horizontal and vertical axes. Referring to the darker side of games played by children and adults, cruelty and aggression feature equally in Nauman's videos of this period in which actors are employed to suggest the thin line between friend and foe in human relations. EM

Knot in Ear, 1967
Wax, 2.7 × 15.2 × 8 cm
Courtesy of the D.Daskalopoulos Collection

Small Butt to Butt, 1989
Polyurethane foam, glue, wire, 49 × 153 × 69 cm
Courtesy of the D.Daskalopoulos Collection

Ernesto Neto
b.1964

The Brazilian artist Erneto Neto is known for his immersive, interactive sculptural environments made using

translucent elasticated fabric. His organic forms and installations directly engage the viewer's body through the senses of smell, touch and sight, following the aims of the Brazilian neo-concrete artists in the late 1950s to introduce a multi-sensorial approach to the art object. Since the late 1980s, when he made minimalist sculptures comprising elements in mutually supportive relations, tension, balance and the relationship between vertical and horizontal have been central to Neto's practice. He attributes this to the extreme landscape of his home city Rio de Janeiro, where the horizontality of the sea intersects abruptly with brutally vertical mountains, and an ever-increasing population struggles to cohabit within the narrowly defined geographical limits. In the early 1990s, Neto began filling membrane-like tubes with ball bearings, lead particles and Styrofoam pellets, later progressing to using aromatic powdered spices. Initially lying in distended sacks on the ground, by the end of the decade they were being stretched between the ceiling and floor. The resulting chamber-like environments recall the intimate spaces inside a body, in which viewers are invited to contemplate and to play. EM

It Happens When the Body is Anatomy of Time, 2000
Lycra tulle, clove, cumin, tumeric, dimensions variable

Courtesy of the D.Daskalopoulos Collection

Francis Picabia
1879–1953

Picabia was a highly versatile artist and created works in a range of styles during his career. The human body and experience were a central motif for the artist, frequently with a focus on the relationship between people and their place in the modern, urban era. Born in Paris, Picabia began drawing as a child and in 1895 he took up studies in fine art at the École des Arts Décoratifs, Paris. From 1909, he explored the 'isms' prevalent in Europe at this time, particularly Cubism. Picabia first visited New York in 1913 when his work was exhibited at the Armory Show. Returning to New York in 1915, he became associated with the city's Dada group and gained recognition for the works that he made during this period. As well as painting, he produced the Dada journal, *391*. Picabia's maverick fascination with the absurd and his often iconoclastic approach had much in common with the concerns of his friend Marcel Duchamp. It was the influence of Duchamp, as well the growing interest in mechanisation in America, that led Picabia to depict machines in his work. He once stated 'The machine has become more than a mere adjunct to life. It is really part of human life – perhaps the very soul.' Picabia was never afraid to court unconventionality, and his works often had hidden ironic meanings. His association with Dada ended in 1921, and after settling in the south of France in the mid-1920s, he began painting figurative images based on photographs of female nudes found in popular magazines. In the final years of his life, he shifted his focus once again, making abstract paintings that explored the physicality of the artist's materials. LA

Girl Born without a Mother (Fille née sans mère), c.1916–17
Gouache and metallic paint on printed paper, 50 × 65 cm

Scottish National Gallery of Modern Art, Edinburgh, purchased 1990, GMA 3545

Pablo Picasso
1881–1973

The most celebrated artist of the twentieth century, Pablo Picasso is best known for his innumerable portraits of his wives and mistresses and his iconic and controversial representations of the female nude. Born in Malaga, Picasso studied art in Barcelona and Madrid before travelling to Paris in 1900. His early melancholic 'Blue Period' featuring characters from his impoverished life on the Bateau-Lavoir was followed by the happier 'Rose Period' warmed by new prosperity and a love affair with a beautiful model. In 1907 his painting depicting five abstracted and distorted nudes – *The Young Ladies of Avignon* (*Les Demoiselles d'Avignon*) – became the inspiration for Cubism, the style he pioneered with Georges Braque. Always fearlessly experimental, Picasso developed a range of signature styles that fused elements of his classical training with cubist deconstruction and primitivist forms, veering between abstraction and figuration, flat stylisation and three-dimensional modelling at will. Involved with Surrealism from 1927, he incorporated mythological figures such as the Minotaur into allegorical representations of both his personal life and war, as in his most famous work, *Guernica*, 1937. Picasso moved permanently to the Côte d'Azur in 1948, where his late work was dominated by the figure of his second wife, Jacqueline Roque. EM

Seated Nude (Nu Assis), 1969
Oil on canvas, 130 × 89 cm

Scottish National Gallery of Modern Art, Edinburgh, on loan from a private collection
GML 1808

Dieter Roth
1930–1998

The iconoclastic art of Dieter Roth is extraordinarily diverse, encompassing graphics, painting, sculpture, assemblages, installations, slides, sound recordings, film and video, as well as numerous foodstuffs and other non-traditional materials. Born Karl-Dietrich Roth in Hanover to a German mother and a Swiss father, he made his first etching in 1946 using metal from a tin can while at secondary school in Switzerland. After training as a commercial/graphic artist in Bern (1947–51), he became friends with Daniel Spoerri, who published Roth's concrete art in his magazine *material*. In 1957 Roth moved to Reykjavik, where he created influential artists' books,

designed jewellery, founded a furniture shop and fathered two sons, before embarking on a peripatetic existence as a visiting professor and resident artist that took him to Philadelphia and Rhode Island, USA, during the 1960s. His many self-portraits make no visual reference to his appearance, but rather to processes of entropy. Reflecting his sense of himself as a constantly shifting and nebulous persona, they present the artist as salad, dog faeces, a splash of chocolate and a bird feeder. Roth drew fluidly, spontaneously and prolifically all his life, reaching a climax of obsessive production during the late 1970s. EM

13 Recalcitrationally Commenced Images of Others, 1978
Thirteen drawings, pencil on paper, each 29.6 × 20.9 cm

Courtesy of the D.Daskalopoulos Collection

8 Timidly Sour Self-farts, 1978
Eight drawings, each pencil on paper, each 29.6 × 20.9 cm

Courtesy of the D.Daskalopoulos Collection

9 Desperately Shit-awful Self-drawings, 1978
Nine drawings, pencil on paper, each 29.6 × 20.9 cm

Courtesy of the D.Daskalopoulos Collection

Schwarze Rose (Black Rose), 1969
Acrylic on wood, 15.5 × 15.7 × 4.5 cm, edition 64/100

Courtesy of the D.Daskalopoulos Collection

Doris Salcedo
b.1958

The art of Doris Salcedo is driven by the trauma of civil war. Born in Bogotá, Colombia, in 1958, Salcedo began making sculpture in New York in the early 1980s while attending New York University, becoming influenced by Joseph Beuys's notion of politically engaged 'social sculpture'. Her return to Colombia in 1985 coincided with an intensification of the war there, inspiring a series of works made from steel-frame hospital furniture roughly cut and welded to metal shelving, suggesting two systems of support tortuously fused together. Subsequent series incorporate traces of traumatic memory such as items of clothing from people found in mass graves, or respond to the stories of children who have witnessed their parents' murder. During the 1990s Salcedo created a series of sculptures comprising old wooden wardrobes, cupboards and chests sealed with cement. Smaller pieces of domestic furniture partially inserted into the cement-filled openings evoke human bodies, their fragility in stark contrast to the harsh industrial resonances of the deadening cement. Using human hair to stitch wooden tables, and pigs' intestine to bind welded metal, Salcedo viscerally invokes the process of trying to heal irreparable emotional and psychological wounds. EM

Untitled, 1995
Wood, cement and steel, 162 × 107 × 45 cm

Courtesy of the D.Daskalopoulos Collection

Kiki Smith
b.1954

Kiki Smith is known for her unconventional depictions of the human body, opening it out to reveal both its internal structure and shell-like skin. Born in Nuremberg, Germany, the daughter of the American sculptor Tony Smith, she had a Catholic upbringing in New Jersey. In 1974 she enrolled in Hartford Art School, Connecticut, but dropped out eighteen months later, moving to New York in 1976, where she joined the artists' collective Colab around 1978. The body as a source of knowledge, spiritual belief and storytelling in literature, history and folklore is central to Smith's work of the 1980s and 1990s. After training as a medical technician in 1985, she created prints and drawings investigating anatomical forms and functions, making sculptures of organs and other body parts from fragile materials such as glass, papier-mâché, terracotta and plaster. In the following decade she addressed issues of feminine subjectivity and physical abjection with life-sized naked figures – made in wax, bronze and paper – presented in vulnerable poses and often trailing bodily fluids. Her more recent imagery incorporates animals, domestic objects and narratives from classical mythology and fairy tales to allude to universal themes of life, death and resurrection. EM

Basin, 1990
Plaster, 33 × 52 × 107 cm

Courtesy of the D.Daskalopoulos Collection

Shitbody, 1992
Papier-mâché, 193 × 143 × 31 cm

Courtesy of the D.Daskalopoulos Collection

Untitled, 1993
Graphite, on metho-cellulose with hand-dyed Nepalese paper, 160 × 47 × 138 cm

Courtesy of the D.Daskalopoulos Collection

Bed with Arms, 1996
Wax, oil encaustic, wood and cotton, 54 × 195 × 75 cm

Courtesy of the D.Daskalopoulos Collection

Rachel Whiteread
b.1963

Based in London, Rachel Whiteread makes sculptures of the spaces inside, under and on top of everyday household objects. She began making casts during her student days at Brighton Polytechnic and at the Slade School of Art in the 1980s, focusing initially on her own body. In 1988, pursuing an impulse for comfort and familiarity, she cast the inside of a wardrobe as a solid form, evoking entombment. Since this time, her work has combined the theme of the human body and its intimate daily ritual with a haunting sense of absence and death. Whiteread uses casting to capture the traces of human presences left on objects and inside rooms with plaster, concrete and a range of synthetic materials. In the early 1990s she pioneered the processes of large-scale casting in rubber and

resin for their organic associations. Recalling abject bodily fluids, the yellow-orange tones of her casts of mattresses, baths and mortuary slabs open up an ambiguous territory where inside and outside coexist. More recent casts derived from shelves of books and architectural features such as staircases are increasingly abstracted, articulating a relationship between physical bodies and the formal structural principles of Minimalism. EM

Slab (Plug), 1994
Rubber, 21 × 76 × 200 cm
Courtesy of the D.Daskalopoulos Collection

Untitled, 2000
Plaster, polystyrene and steel, 92 × 120 × 22 cm
Courtesy of the D.Daskalopoulos Collection

Sue Williams
b.1954

The feminist painter Sue Williams combines themes of gender politics and the sexual body in her art. Born in Chicago Heights, Illinois, she graduated in fine art at the California Institute of the Arts in 1976, before moving permanently to New York. During the 1980s she painted comic-based scenes featuring ironic twists on gender relations. Fuelled by her own experience as a battered woman, these became increasingly biting in their attack on the acceptance of male sexism against women that she perceived in the art world and everyday life. Her work drew critical attention as part of a new figure-based approach to painting in the early 1990s, when she filled her canvases with naively-drawn characters – human and animal – engaged in abject and obscene activities. Williams's gruesome cartoons of rape, incest and other forms of sexual violence satirically challenge attitudes towards women's bodies and the politics of sexual allegiances. Around 1994, she stopped using text, reducing her crudely expressive figures to fragmented abstractions of the human form. Depicted in unflattering detail, wrinkles and stray hairs adorn orifices and genitalia that float over canvases, appearing from a distance to depict innocently graceful arabesque-like patterns before morphing into more painterly forms. EM

Family Room, 1994
Ink on paper from spiral block, collage on printed paper, 30 × 44 cm
Courtesy of the D.Daskalopoulos Collection

Creamy Floral, 1995
Ink on wallpaper, 44.5 × 33 cm
Courtesy of the D.Daskalopoulos Collection

Busy with Calm Background, 1995
Ink on paper, collage on wallpaper, 44.5 × 33 cm
Courtesy of the D.Daskalopoulos Collection

Francesca Woodman
1958–1981

Francesca Woodman took her first self-portrait photograph at the age of thirteen. From then, up until her suicide in New York at the age of twenty-two, she produced several hundred photographs in which she explored issues of gender and of the self through images of her body in relation to its surroundings. Born in Denver, Colorado, into a family of artists, Woodman studied at Rhode Island School of Design from 1975 to 1979, receiving a grant to spend a year in Rome to continue her studies in 1977. Here she was influenced by the symbolic work of Max Klinger and had her first solo exhibition at a bookshop and gallery specialising in Surrealism. Often featuring surrealist props such as mirrors, gloves, birds and bowls, Woodman's photographs show her body doubled, reflected, fragmented and dissolving, both celebrating and challenging the camera's objectifying gaze. Almost always black and white, the photographs' small and intimate format, soft focus and decaying architectural settings recall the photography of earlier eras. Using long exposures, Woodman subjected her body to the effects of time, causing it to float and evaporate like smoke as it melts into or emerges from her surroundings. EM

Self-deceit #1 (Roma), 1977–8
Vintage silver gelatine print, 9.2 × 9.2 cm
Scottish National Gallery of Modern Art, Edinburgh, purchased with assistance from the Art Fund 2005, GMA 4768

Self-deceit #4 (Roma), 1977–8
Vintage silver gelatine print, 9.8 × 9.8 cm
Scottish National Gallery of Modern Art, Edinburgh, purchased with assistance from the Art Fund 2005, GMA 4769

Self-deceit #5 (Roma), 1977–8
Vintage silver gelatine print, 9.2 × 9.2 cm
Scottish National Gallery of Modern Art, Edinburgh, purchased with assistance from the Art Fund 2005, GMA 4770

Self-deceit #6 (Roma), 1977–8
Vintage silver gelatine print, 8.5 × 8.5 cm
Scottish National Gallery of Modern Art, Edinburgh, purchased with assistance from the Art Fund 2005, GMA 4771

Self-deceit, 1977–8
Vintage silver gelatine print, 8.5 × 8.8 cm
Scottish National Gallery of Modern Art, Edinburgh, purchased with assistance from the Art Fund 2005, GMA 4772

SELECT BIBLIOGRAPHY

BASUALDO ET AL. 2000
Carlos Basualdo, Nancy Princenthal and Andreas Huyssen, *Doris Salcedo*, London and New York, 2000

BERNADAC AND OBRIST 1998
Marie-Laure Bernadac and Hans-Ulrich Obrist (eds), *Louise Bourgeois, Destruction of the Father/Reconstruction of the Father: Writings and Interviews 1923–1997*, London, 1998

BILBAO 2011
Simon Critchley, Jamieson Webster and Nancy Spector, *The Luminous Interval: The D.Daskalopoulos Collection*, exh. cat., Guggenheim Museum, Bilbao, 2011

EDINBURGH 2006
Keith Hartley, Holger Broeker, Jaroslav Andel and Ian Rankin, *Douglas Gordon: Superhumanatural*, exh. cat., Scottish National Gallery of Modern Art, Edinburgh, 2006

EDINBURGH 2010
Patrick Elliott, *Another World: Dalí, Miró and the Surrealists*, exh. cat., Scottish National Gallery of Modern Art, Edinburgh, 2010

ELLIOTT 1999
Patrick Elliott, *A Companion Guide to the Scottish National Gallery of Modern Art*, Edinburgh, 1999

FOSTER 1995
Hal Foster, *Compulsive Beauty*, Cambridge, Mass., and London, 1995

GOLDBERG 2001
RoseLee Goldberg, *Performance Art: From Futurism to the Present*, London, 1979, revised edition, 2001

HEARTNEY ET AL. 2007
Eleanor Heartney et al., *After the Revolution: Women Who Transformed Contemporary Art*, Munich, Berlin, London, New York, 2007

HOPKINS 2007
David Hopkins, *Dada's Boys: Masculinity after Duchamp*, New Haven and London, 2007

KRAUSS 1993
Rosalind Krauss, *The Optical Unconscious*, Cambridge, Mass., 1993

KRAYNAK 1999
Janet Kraynak (ed.), *Please Pay Attention Please: Bruce Nauman's Words: Writings and Interviews*, Cambridge, Mass., and London, 1999

LIVERPOOL 1996
Rosalind Krauss, Bartomeu Mari, Stuart Morgan and Michael Tarantino, *Rachel Whiteread: Shedding Life*, exh. cat., Tate Gallery, Liverpool, 1996

LIVERPOOL 2006
Laurence Sillars, *Bruce Nauman: Make Me Think Me*, exh. cat., Tate Liverpool, 2006

LONDON 1999
Mike Kelley: Exploded Fortress of Solitude, exh. cat., Gagosian Gallery, London, 1999

LONDON 2004
Mark Sladen (ed.), *Helen Chadwick*, exh.cat., Barbican Art Gallery, London, 2004

LONDON 2010
Ernesto Neto: The Edges of the World, exh. cat., Hayward Gallery, London, 2010

LONDON 2010 A
Achim Borchardt-Hume, *Keeping it Real: from the Ready-made to the Everyday: The D.Daskalopoulos Collection*, exh. cat., Whitechapel Art Gallery, London, 2010

LONDON AND LIVERPOOL 1993
Judith Nesbitt (ed.), *Robert Gober*, exh. cat., Serpentine Gallery, London and Tate Gallery Liverpool, 1993

MAHON 2005
Alyce Mahon, *Surrealism and the Politics of Eros: 1938–1968*, London, 2005

MANCHESTER 2010
Subversive Spaces: Surrealism and Contemporary Art, exh. cat., Whitworth Art Gallery, Manchester, 2010

MICHELY AND MESCH 2007
Viola Michely and Claudia Mesch (eds), *Joseph Beuys: The Reader*, New York, 2007

MINNEAPOLIS 2005
Siri Engberg (ed.), *Kiki Smith: A Gathering: 1980–2005*, exh. cat., Walker Art Center, Minneapolis, 2005

NIXON 2005
Mignon Nixon, *Fantastic Reality: Louise Bourgeois and a Story of Modern Art*, Cambridge, Mass., and London, 2005

O'REILLY 2009
Sally O'Reilly, *The Body in Contemporary Art*, London, 2009

OSLO 2001
Elisabet Hanssen, *Marina Abramović: Cleaning the Mirror 1*, exh. cat., National Museum of Contemporary Art, Oslo, 2001

OSLO 2003
Matthew Barney – The Cremaster Cycle, exh. cat., Astrup Fearnley Museet for Moderne Kunst, Oslo, 2003

PARKINSON 2008
Gavin Parkinson, *The Duchamp Book*, London, 2008

ROGERS AND CHARLWOOD 2011
Connie Rogers and Lindsay Charlwood (eds), *L.A. Object & David Hammons Body Prints*, New York, 2011

RUGOFF ET AL. 1996
R. Rugoff, K. Stiles and G. Di Pietrantonio, *Paul McCarthy*, London, 1996

STILES AND SELZ 1996
Kristine Stiles and Peter Selz (eds), *Theories and Documents of Contemporary Art: A Sourcebook of Artist's Writings*, Berkeley and Los Angeles, 1996

TOWNSEND 2006
Chris Townsend, *Francesca Woodman*, London and New York, 2006

VISCHER 2007
Theodora Vischer (ed.), *Robert Gober: Sculptures and Installations 1979–2007*, Basel and Steidl, Göttingen, 2007

WARR 2012
Tracey Warr (ed.), *The Artist's Body*, London and New York, 2000, revised edition, 2012

WASHINGTON 2004
Olga M. Viso (ed.), *Ana Mendieta Earth Body: Sculpture and Performance, 1972–1985*, exh. cat., Hirschhorn Museum, Smithsonian Museum, Washington, DC, 2004

WESTCOTT 2010
James Westcott, *When Marina Abramović Dies: A Biography*, Cambridge, Mass. and London, 2010

ZURICH 2007
Dieter Roth – Drawings, exh. cat., Galerie Eva Presenhuber, Zurich, 2007

COPYRIGHT CREDITS

Marina Abramović 32 © the artist

Abramović/Ulay 58 © Giovanna dal Magro and Lisson Gallery, London, courtesy of The Marina Abramović Archives

Jean Arp 24 © DACS 2013

Balthus (Balthasar Klossowski de Rola) 2, © ADAGP, Paris and DACS, London 2013

Matthew Barney 14, 15, 16, 17, 18, 19 © Matthew Barney, courtesy Gladstone Gallery, New York and Brussels

Hans Bellmer 29 © ADAGP, Paris and DACS, London 2013

Joseph Beuys 20, 22, 33 © DACS 2013

Louise Bourgeois 44, 47 © Louise Bourgeois Trust/Licensed by VAGA, NY

Boyle Family 37 © Boyle Family. All rights reserved, DACS 2013

André Breton 56 © DACS 2013

Günter Brus 64 © Gunter Brus

Vlassis Caniaris 53, courtesy of the artist and The Breeder, Athens

Helen Chadwick 13, 21 © The Helen Chadwick Foundation

Salvador Dalí 57 © DACS 2013

Paul Delvaux 41 © DACS 2013

Otto Dix 3 © DACS 2013

Marcel Duchamp 25, 48, 49, 55, 56 © Succession Marcel Duchamp/ADAGP, Paris and DACS, London 2013

Tracey Emin 11 © Tracey Emin. All rights reserved, DACS 2013

Max Ernst 5 © ADAGP, Paris and DACS, London 2013

Robert Gober 6, 7, 9, 26, 46, 59, 60, 61 © Robert Gober, courtesy Matthew Marks Gallery

Douglas Gordon 12 © the artist

David Hammons 38, 39, 40 © the artist, courtesy of the artist

Mona Hatoum 30 © Mona Hatoum/White Cube

Mike Kelley 27, 28, 31, 62 © Estate of Mike Kelley. All rights reserved Courtesy of Mike Kelley Foundation for the Arts

William Kentridge 50, courtesy of the artist and Marian Goodman Gallery

Stathis Logothetis 63, courtesy of the artist

Sarah Lucas 2, 27, 35, 36 © the artist, courtesy Sadie Coles HQ, London

René Magritte 1, 8, 51 © ADAGP, Paris and DACS, London 2013

Paul McCarthy and Damon McCarthy 23 courtesy the artist and Hauser & Wirth

Ana Mendieta 65, 66 courtesy Galerie Lelong and Alison Jacques Gallery

Joan Miró 54 © Succession Miro/ADAGP, Paris and DACS, London 2013

Bruce Nauman 45, 51, 52 © ARS, NY and DACS, London 2013

Ernesto Neto 22 © The artist

Francis Picabia 55 © ADAGP, Paris and DACS, London 2013

Pablo Picasso 4 © Succession Picasso/DACS, London 2013

Dieter Roth 34 © Dieter Roth Estate, courtesy Hauser & Wirth

Doris Salcedo 20, Image courtesy Alexander and Bonin, New York

Kiki Smith 42 © Kiki Smith, courtesy Pace Gallery

Rachel Whiteread 45, 46, courtesy of the artist, Luhring Augustine, New York, and Gagosian Gallery

Sue Williams 43, courtesy 303 Gallery, New York

Francesca Woodman 10 © George and Betty Woodman

Every effort has been made to contact the copyright holders of the material in this book. If any rights have been omitted, the publisher offers their apologies and will rectify this in any subsequent edition following notification.

PHOTOGRAPHIC CREDITS

John McKenzie all exhibition installation photography: 2, 6, 7, 9, 12,–24, 26–28, 30–33, 38, 42, 45, 46, 48–53, 55, 59, 60–63, 66

AIC Photography 1

Christopher Burke 44, 47

D.Daskalopoulos Collection 34

Alexandros Filippidis 39, 40, 43

Galerie Lelong, New York 65, 66

Michael James O'Brien 15, 18, 19

Antonia Reeve 3, 4, 5, 8, 10, 11, 29, 35, 36, 37, 41, 51, 54, 56, 57, 64

Ann-Marie Rounkle 23

Sotheby's Photography 25

Chris Winget 16, 17